A SHAKER SISTER'S DRAWINGS

A SHAKER SISTER'S DRAWINGS

WILD PLANTS ILLUSTRATED BY CORA HELENA SARLE

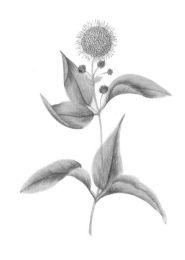

INTRODUCTION BY JUNE SPRIGG TOOLEY
AFTERWORD BY SCOTT T. SWANK

THE MONACELLI PRESS

A DAVID LARKIN BOOK

First published in the United States of America in 1997 by
The Monacelli Press, Inc.
10 East 92nd Street, New York, New York 10128.

Library of Congress Cataloging-in-Publication Data
Sarle, Cora Helena, 1867–1956.
A Shaker sister's drawings : wild plants illustrated by
Cora Helena Sarle / introduction by June Sprigg Tooley ;
afterword by Scott T. Swank.
p. cm.
ISBN 1-885254-52-0
1. Botany—New Hampshire—Pictorial works.
2. Botanical illustration—New Hampshire. I. Title
QK174.S27 1997
581.9742'022'2—dc21 96-40516

Edited and designed by David Larkin
Printed and bound in Hong Kong

While sowing by the wayside
Or oft in gardens fair,
O scatter thoughts of gladness
And blessing ev'rywhere.
In words of peace and profit,
In deeds of love and care,
That wilderness and desert
May bloom with harvest rare.

"Sowing to the Spirit" from the *Shaker Hymnal*,
Canterbury, New Hampshire, 1908

Introduction

WHEN I WAS NINETEEN, I went to Canterbury, New Hampshire, to live and work with the Shakers. Every day that summer of 1972, I spent hours talking with the Shakers, a half-dozen Sisters in their seventies, eighties, and nineties. It was a wonderful time. I got six more grandmas; they got a youngster who couldn't get enough of their stories of the "old Shakers" who built their world on faith and love, and whose accomplishments remain an admirable part of the American legacy.

When my head grew full and my young legs restless, I'd go for walks in the country around the lovely white hilltop village. In July the roadsides were generous with blossom—cornflowers, daylilies, butter-and-eggs, devil's paintbrush, brown-eyed Susans—but bountiful by what I learned to understand as New England standards. New England seldom overwhelms. No lush, hothouse mass, no gaudy showstoppers here: I had to be still and look closely to appreciate this quiet creation. The God who sketched this Yankee Eden measured fruitfulness with reserve.

That summer the Shakers told me so many stories about Elder Henry Clay Blinn, the flower of Canterbury's vanished brotherhood, that I soon felt as though I knew him, or at any rate, that Henry was around but had just stepped out the door. I read every word of Henry's manuscript journals and letters and came to recognize his handwriting before I found his signature. The spirit of this gentle schoolteacher, spiritual leader, and good-humored polymath hovered over and throughout the village. The Shakers, whose lives were built on the bedrock of Christian faith in the everlasting life of the spirit, were matter-of-fact about sensing the spiritual presence of bygone Believers. I was spellbound by their accounts of communication with loved ones. An awareness of benign, invisible companions touched occasional outsiders, too, who paid attention to their sixth sense. For years afterward, Eldress Gertrude Soule delighted in quoting a visitor who likened the presence she felt to a "blanket of blessing" over the village.

I could not absorb enough, and I didn't want to forget a bit, so I sketched endlessly that summer. It tickled me deeply to learn that I had a twin a century earlier. Cora Helena Sarle, known better by her middle name, was fifteen years old when she came to Canterbury in 1882, one of many hundreds of children over time who found a home with the Shakers. Elder Henry himself had come to the Shakers in 1838 when he was fourteen. By the time young Helena knew him, Henry was the beloved spiritual patriarch of the community, hailed in his own time as the last of the great early leaders. The progressive spirit of Elder Henry and his partners among the Sisters was responsible for Canterbury's survival into the late twentieth century. While most of America's other Shaker settlements dwindled and died around the turn of the century, the Canterbury leaders made their community a warm and attractive place, where the young people required for the next generation of this celibate society were more inclined to stay than to go. Like all the children raised by the Shakers, Helena was free to choose when she came of age.

Helena had been with the Shakers for just a year when Elder Henry saw an opportunity for her to improve her fragile health while using her artistic gifts for the good of the communal family. He asked her to illustrate a book of botanical drawings of native plants to help teach the younger children. Elder Henry himself researched and wrote the text.

Tramping around the fields and woods in fresh air strengthened the young woman physically, as Henry intended. His kindness and wisdom in inviting Helena into a project that brought her so much into the heart of the community reaped their rewards, as well. At age twenty-one, Helena signed the Covenant and committed herself to the Shaker life she was to enjoy for nearly seventy more years. The work of Elder Henry and other mentors bore fine fruit. Helena grew into graceful, creative Shaker womanhood, serving God and her community with her gifts for painting, cooking, needlework, and music. Most of all, she loved fun. With Helena came the joys of sledding parties and popcorn parties, candy making and maple "sugar on snow," trips to the seashore, fishing parties, and picnics. Helena, nearing forty when Elder Henry died in 1905, picked up what old age made him lay down and devoted herself to the community's young people. She was "Grammy" to the children who adored her.

So began this inspired collaboration, in love and respect between the generations—Henry, the born teacher, perceiving young Helena's aptitude with pen and brush; Helena, bright and pleased in that wondrous, special way of teenagers to be finding her God-given talent, trying her hand at a rendering of one plant, then another, and another, until more than 180 of her delicate watercolor drawings were gathered in two volumes. There is something in the style of Helena's drawings that distinguishes them from the idealized pleasantry of watercolor renderings that were fashionable among "ladies" of the period. Was the young Helena shown any of the sacred "gift drawings" produced by Shaker visionary artists, almost all women, some forty years earlier? If so, did the simple, stylized drawings of flowers and trees that the artists received in visions of the "spirit world" shape the way Helena saw flowers and shrubs in the natural world? The observer is struck by Helena's straight stalks, the symmetry she perceived in nature, her use of space, and the economy of layout on every page, which allowed no room for mistakes. By the late nineteenth century, when Helena was beginning to embrace Shaker life, the "gift drawings" and other relics of the "era of manifestations" in the 1840s and 1850s were packed away, vestiges of an earlier spiritual zeal, more full of wonders, less genteel.

Helena's botanical drawings remained in Canterbury Shaker Village throughout her life, a treasured family heirloom. In time this charming and important work by Elder Henry Blinn and Sister Cora Helena Sarle was acquired by the late Milton Sherman, a respected collector of Shaker artifacts, imprints, and manuscripts. Its recent return to Canterbury Shaker Village is the occasion for celebration and the preparation of this lovely facsimile edition. May you linger over its pages and, in stillness and pleasure, awaken to the rare harvest within.

JUNE SPRIGG TOOLEY

Notebook One

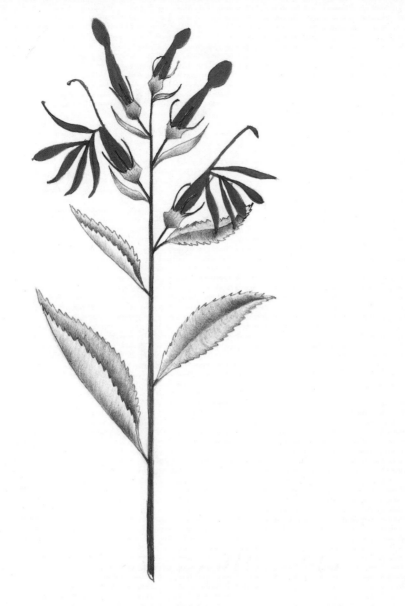

Order Lobeliaceae.

Lobelia Cardinalis.

Cardinal Flower.

A tall species frequent in meadows and along streams. Can to Car & W to Ill.
Stem from 2 to 4 feet. July & Aug.

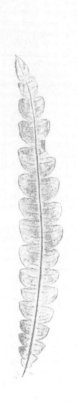
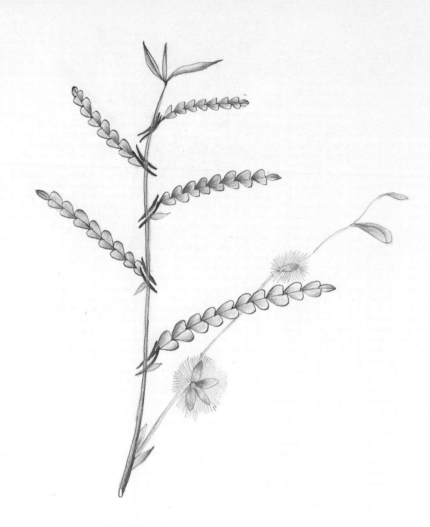

Order. Myricaceae.

Comptonia asplenifolia.

Sweet Fern.

A well Known, handsome aromatic shrub, common in pastures and on hill sides. The main stem is covered with a rusty, brown bark, which becomes reddish in the branches, and white downy in the young shoots. Leaves numerous. Fertile flowers in a dense, rounded burr or head situated below the barren ones.

May.

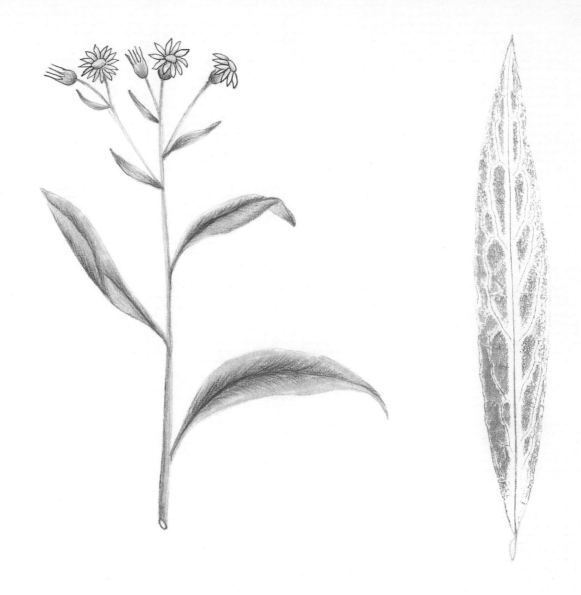

Order Compositae.

Diplopappus umbellatus.

Aster.

Lowgrounds, river banks, fields, New England to
La. Stem 3 to 4 ft high.

Aug & Sept.

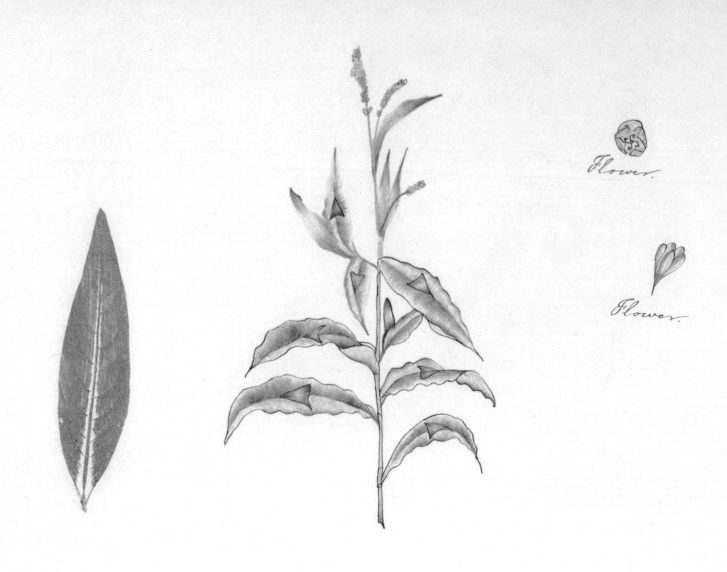

Flower.

Flower.

Order Polygonaceae.

Polygonum Persicaria.

Heart-weed. Smart-weed.

The leaves are marked with a brownish spot.
Common about buildings and fences, wet grounds.
Leaves two to four inches long. Stem leafy, one to two
feet high. June — Aug.

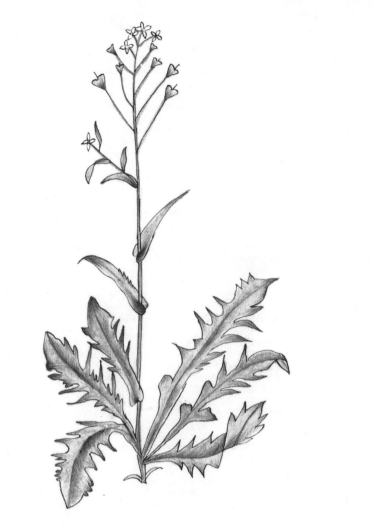

Order Cruciferae.

Capsella Bursa pastoris.

Shepherd's Purse.

A common weed, found everywhere in fields, pastures and road sides. Stem 6-8-12 inches high. Stem leaves are smaller than the root leaves and are half clasping at the stem. Silicle smoothe, triangular. Apr — Sept.

6

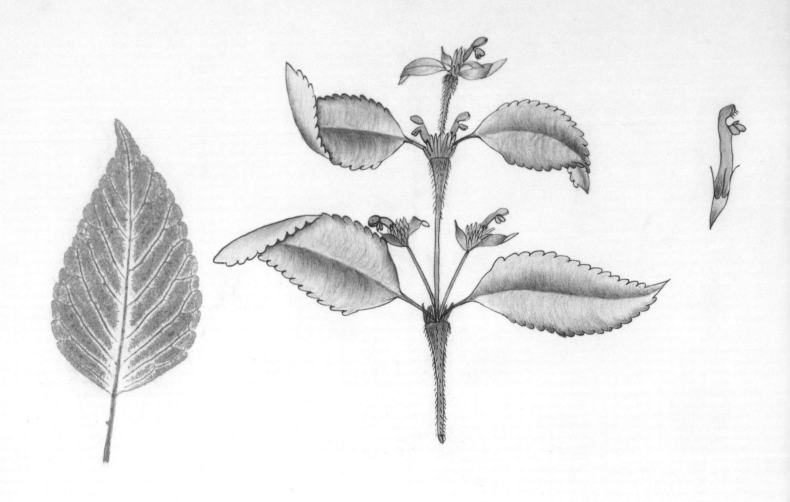

Order Labiatae.
Galeopsis tetrahit.

Hemp Nettle.

A common weed in waste and cultivated
grounds, in Northern States. Stem covered with de-
flexed bristles. Internodes thickened upwards.
June, July.

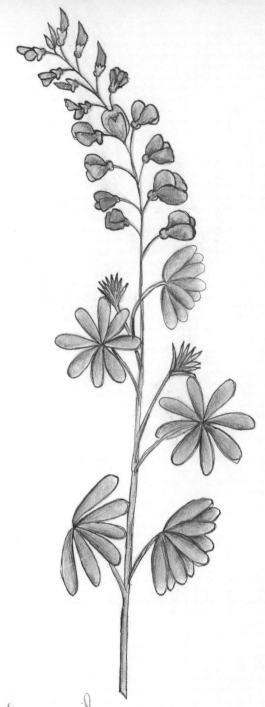

Order Compositae.

Maruta cotula.

Mayweed.

Found in waste places, in
hard soils, especially by road
sides, in large patches. The plant
ill scented.

June & Sept.

Order Leguminosae

Lupinus perennis.

Lupine.

In sandy woods and hills.
Canada to Florida. It is called
Sun-dial from the circumstance of
its leaves turning to face the sun from
morning till night.

May & June.

8

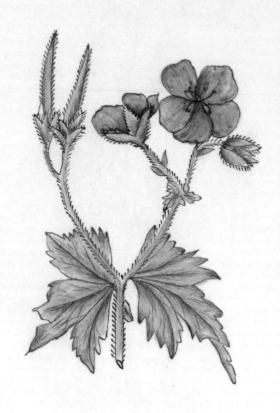

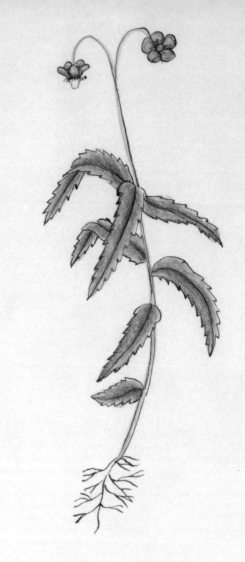

Order Geraniaceae.

Geranium maculatum.

Spotted Geranium.

In dry, rocky places. Can
to Na. Stem reddish. It has a
disagreeable smell.

May to Sept.

Order Ericaceae.

Chimaphila maculata.

Princes Pine.

In dry woods. A common, little
evergreen, Can & Northern States.

July.

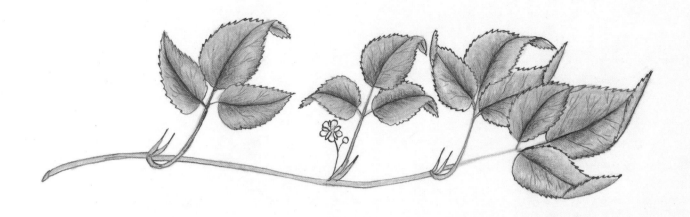

Order Rosaceae.

Rubus hispidus.

Trailing Blackberry.

In damp woods & by the road side. Can. to Carolina.

Trailing several feet. May & June.

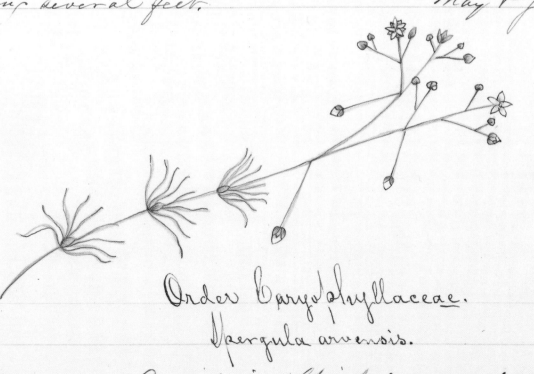

Order Caryophyllaceae.

Spergula arvensis.

Spurry. A weed in cultivated grounds. Can to Ga.

May. Aug.

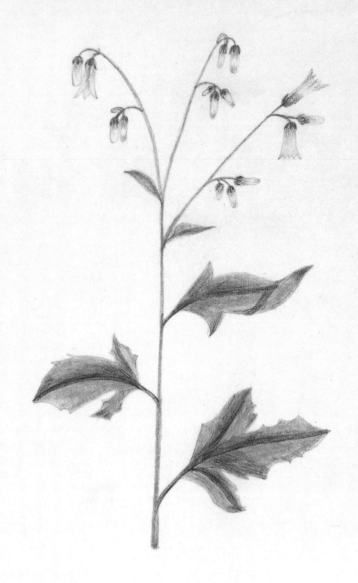

Order Compositae.

Nabalus altissimus.

Rattle Flower.

Tall, with yellowish, nodding flowers, in woods New-
foundland, to New England and Kentucky. Stem 3 to 5 ft.
high.

Aug.

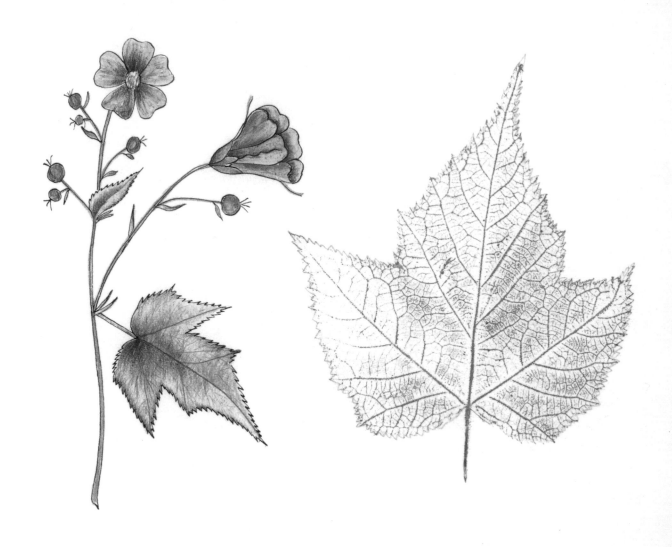

Order Rosaceae.
Rubus odoratus.

Mulberry.

A fine flowering shrub. in upland woods, U.S.
and Brit. Amer. common. Fruit bright red. sweet.
Fruit ripe in Aug. Flowers in June and July.

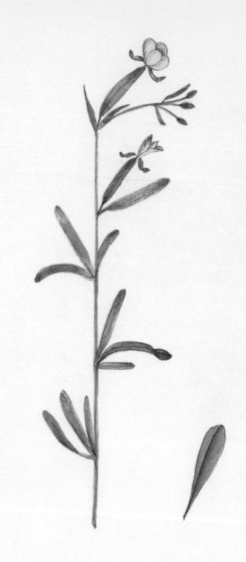

Order Onagraceae.

Oenothera pumila.

Evening Primrose.

A small, half erect plant, common in grass lands, Can to So Car.

June. Aug.

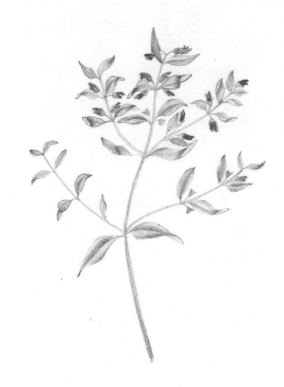

Order Labiatae.
Hedeoma pulegioides.
Amer. Pennyroyal. Squaw mint.
Fragrant. A small sweet scented herb, and
held in high repute. Abundant in dry pastures.
Can. and U. S. Flowering all summer.

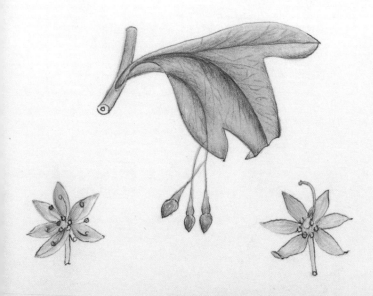

Order Lauraceae.
Sassafras officinale.
Sassafras.
Grows in the U. S. & Can. Every
part of the tree has a pleasant
fragrance & an aromatic taste.
Apr. June.

14

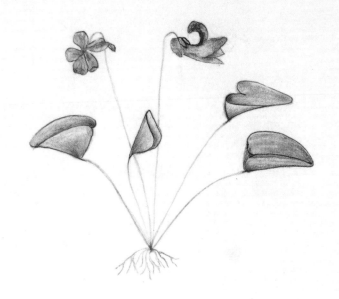

Order Violaceae.
Viola cucullata.

Hood leaved violet.

This is one of the most common kinds of violet, found in low, grassy woods from Arctic Amer. to Florida.
Apr. May.

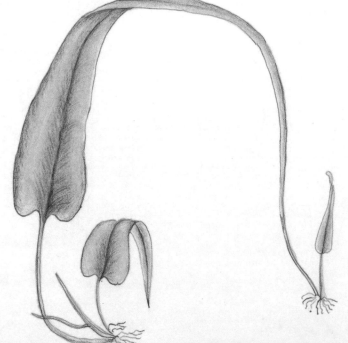

Order Filices.

Antigramma rhizophylla.
Walking Fern.

This singular fern grows in rocky woods, not very common.
July.

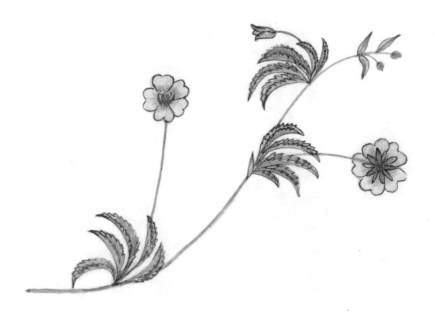

Order Rosaceae.

Potentilla Canadensis.

Cinquefoil. Five finger.

Common in fields & thickets. U.S. & Can.

Apr. Aug.

Order Coniferae.

Larix Americana.

Larch. Tamarack.

A beautiful tree in forests from Can to Penn.

Apr. May.

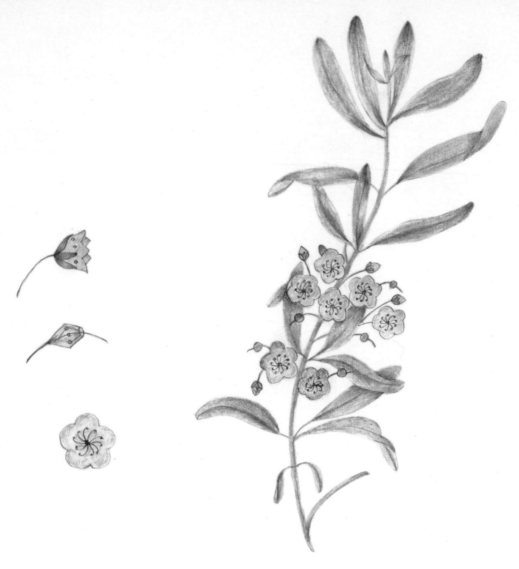

Order Ericaceae.
Kalmia angustifolia.
Sheep poison. Calico Bush.
 Found in woods and by the road side from
Can. to Car. Said to be poisonous to cattle.
 June.

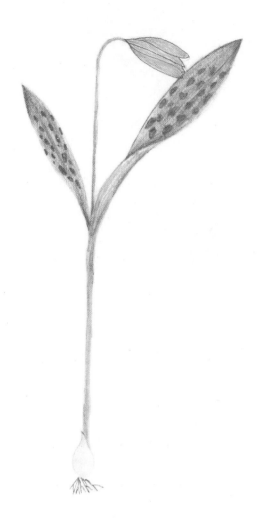

Order Liliaceae.
Erythronium Americanum.
Dog toothed violet. Yellow Erythronium.

A beautiful little plant, among the earliest of our vernal flowers. Found in the woods and by the side of the highway, in rich open grounds, U. S. and Can.

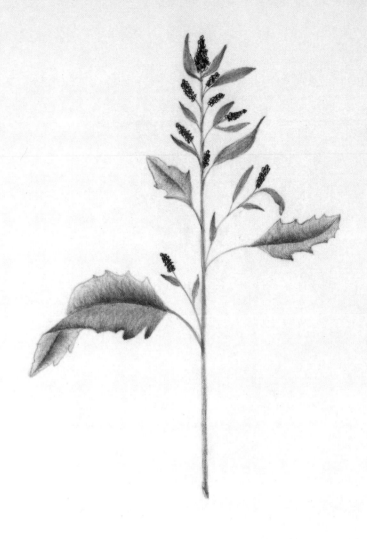

Order Chenopodiaceae.
Chenopodium album.

Pigweed.

The most common of weeds in fields and gardens.

July, Sept.

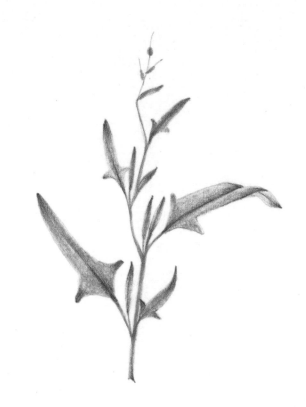

Order Polygonaceae.

Rumex acetosella.

Field sorrel. Sheep sorrel.

A common weed in pastures and waste grounds throughout the U.S. prefering dry, hard soils.

June, Aug.

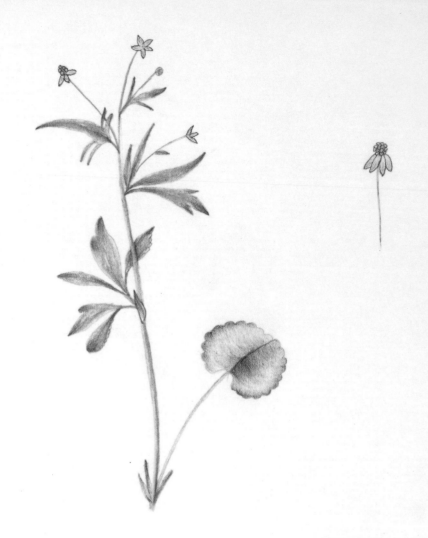

Order Ranunculaceae.
Ranunculus abortivus.

Round leaved crowfoot.

A pretty species in woods and by road sides.

Can to Ark. Remarkable for its dissimularity of
root and stem leaves. May, June.

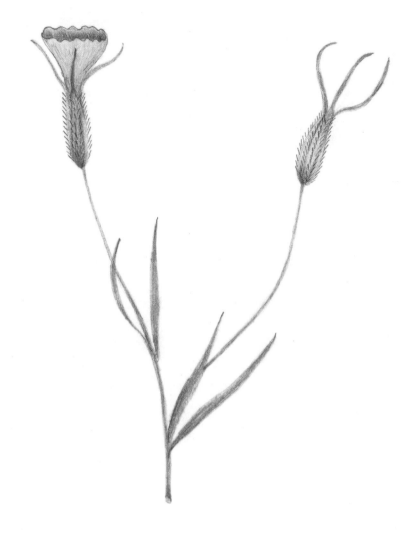

Order Caryophyllaceae.

Agrostemma Githago.

Corn cockle.

A handsome weed, growing in fields of
wheat or other grains. July.

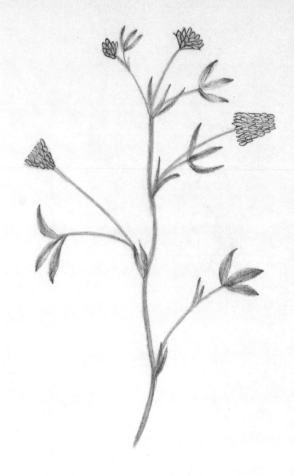

Order Leguminosae
Trifolium procumbens.
Yellow Clover.
In dry soils, N.H. to Va. Flowers at
length reflexed. June. July.

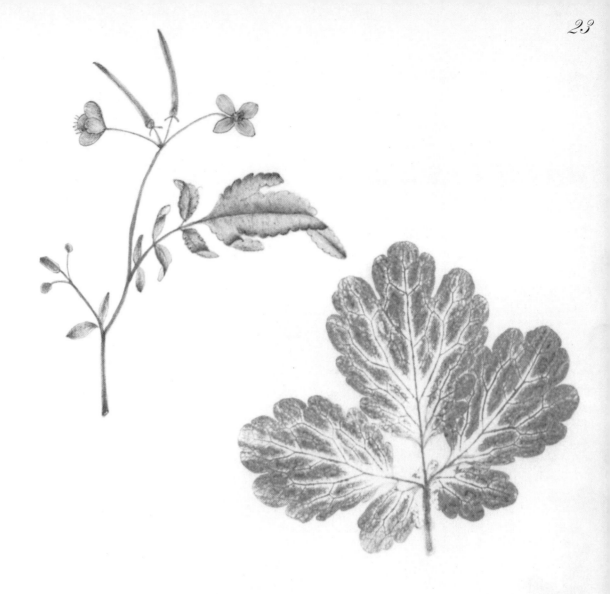

Order Papaveraceae.

Chelidonium majus.

Celandine.

Grows by road sides and fences. Has abundant bright yellow juice. It is used to destroy warts. May, Oct.

24

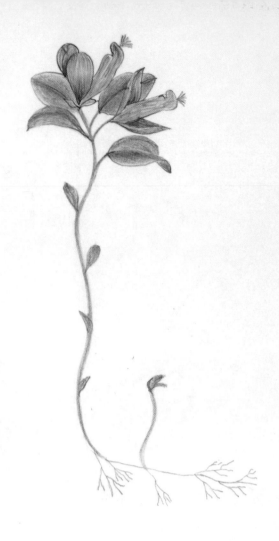

Order Polygalaceae.
Polygala paucifolia.

Milkwort.

In woods and swamps from Can to Ga.
Stem from 3 to 4 inches high. Bears from 2 to 4 flowers.
May.

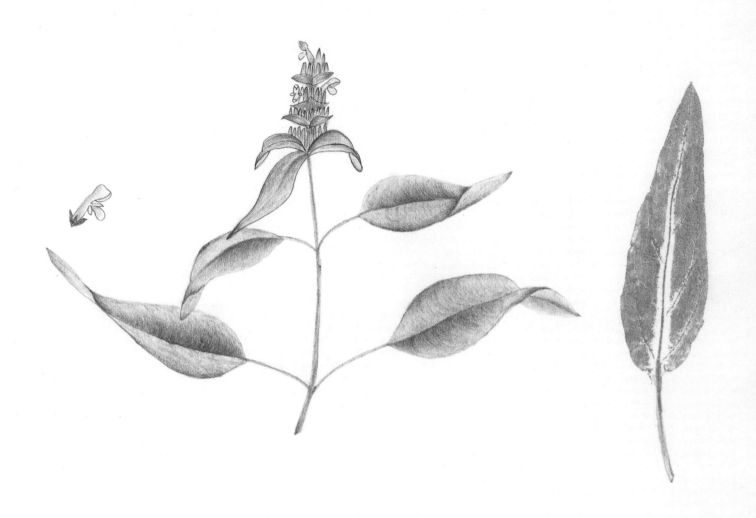

Order Labiatae.
Brunella vulgaris.

Self heal. Blue curls.

A common plant in fields and low grounds.
North Amer. lat 33° to the Arctic sea. Flowering
all summer.

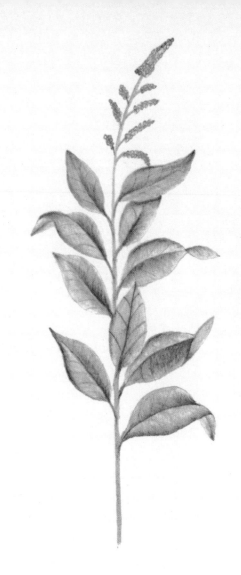

Order Rosaceae.
Spirea tomentosa.

Hardhack.

A small shrub, common in pastures and low grounds, Can. and U.S. The fruit in winter furnishes food for the snow birds.

July. Aug.

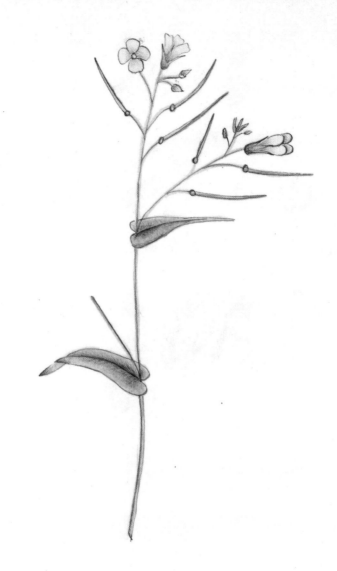

Order Cruciferae.
Brassica campestris.

Cole.

Cultivated fields and waste places.

Jn & July.

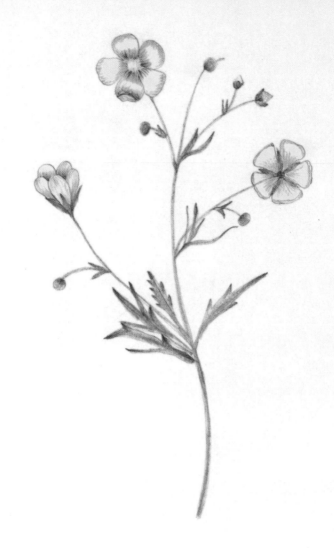

Order Ranunculaceae.

Ranunculus acris.

Buttercups.

This is the most common species in N.E.
and Can, in fields and pastures.

June, Sept.

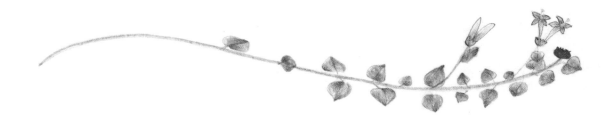

Order Rubiaceae.

Mitchella repens.

Partridge Berry.

A little prostrate plant, found in woods throughout the U. S. and Can. Fruit well flavored but dry. June.

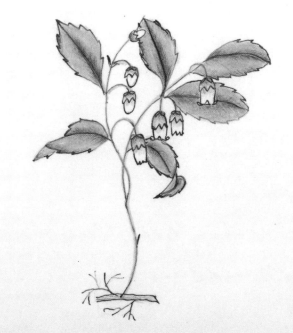

Order Ericaceae.

Gaultheria procumbens.

Checkerberry.

Common in woods & pastures Can. to Ky.

Jn. & Sept.

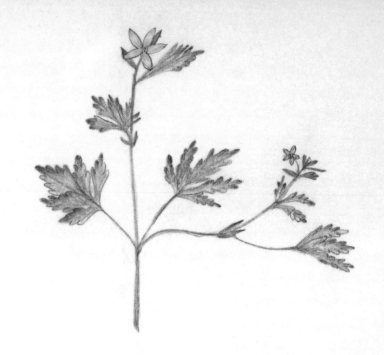

Order Rosaceae.

Potentilla argentea.

Silver weed.

A fine species on wet grounds, meadows and by road sides, N. Eng to Arctic Amr. Leaves silvery white beneath. June, Sept.

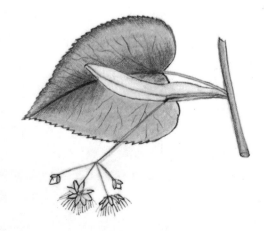

Order Tiliaceae.

Tilia Americana.

Bass wood.

A common forest tree in the northern & middle states.
 June.

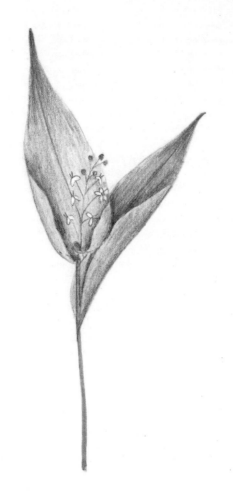

Order Liliaceae.
Majanthemum bifolium.
Two leaved Solomon's Seal.

A small plant upon the edges of woodlands.
Can. and N. Eng. and west to Wis. Berries pale
red, speckled with purple. May.

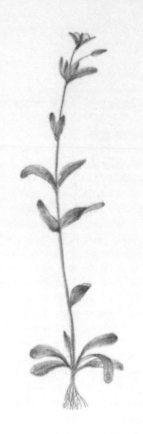

Order Caryophyllaceae.
Cerastium vulgatum.
Mouse ear Chick weed.
Grows in fields and waste grounds. Can.
and U.S. Flowering all summer.

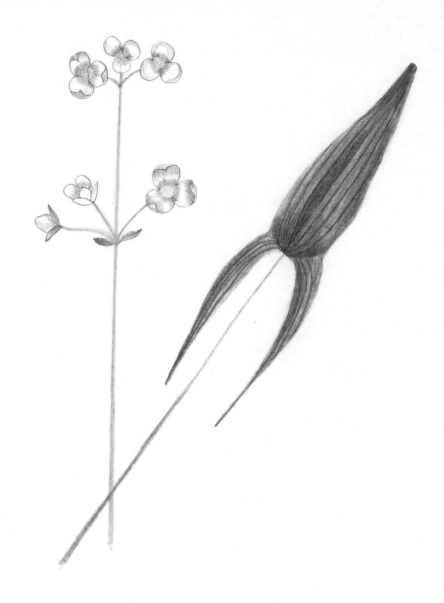

Order Alismaceae.
Sagittaria variabilis.
Arrow Head.
 A curious aquatic, conspicuous among
the rushes and sedges of sluggish waters, Can.
and U. S. July.- Aug.

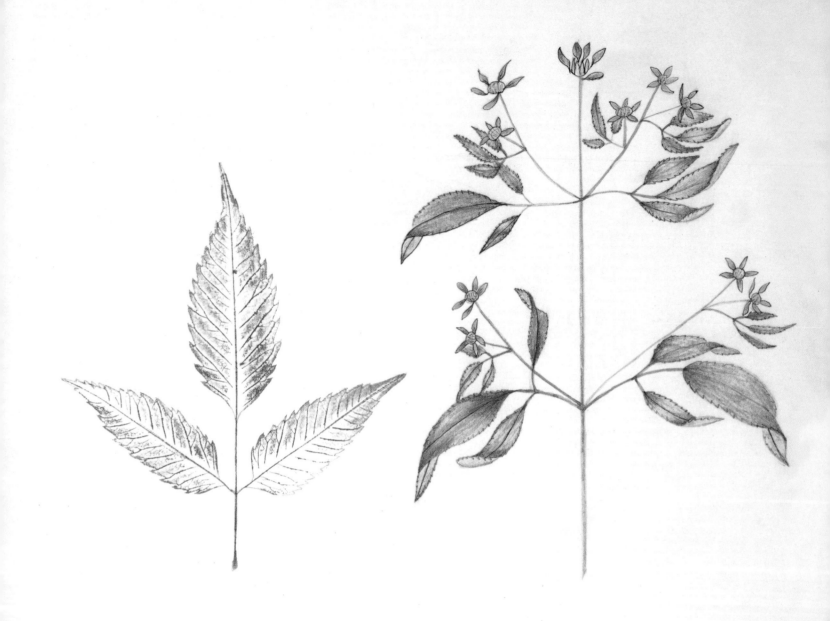

Order Compositae.
Bidens frondosa.
Leafy Burr Marigold. Beggar ticks.
Fields and hedges. Can to Ga.
July. Sept.

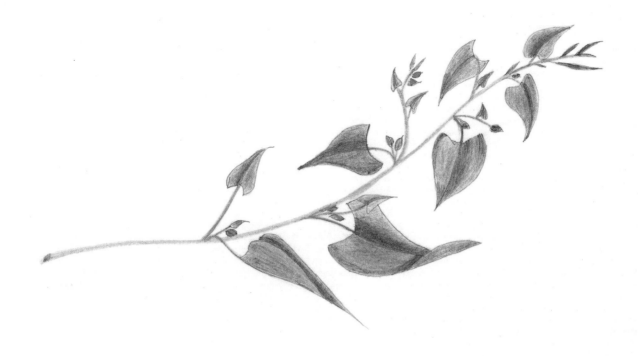

Order Polygonaceae.

Polygonum dumetorium.

Hedge Bindweed,

Thickets. Can & U.S. Climbing over bushes.

July & Sept.

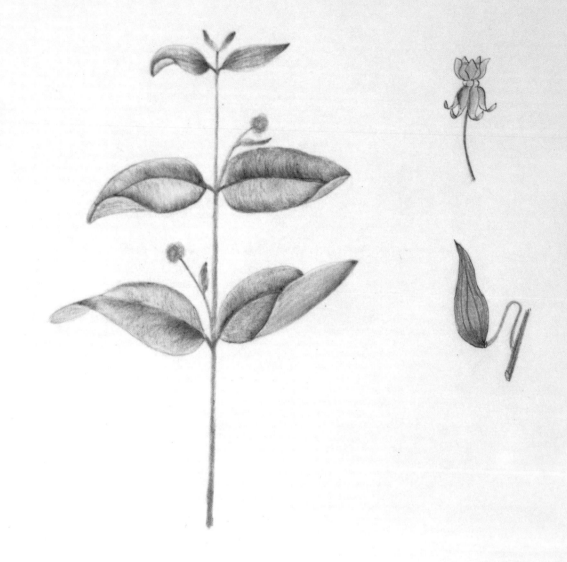

Order Asclepiadaceae.
Asclepias cornuti.
Common Silkweed.

A common, very milky herb, 3 to 4 ft. high, in hedges and road sides. Pods full of seeds with their long silk.

July.

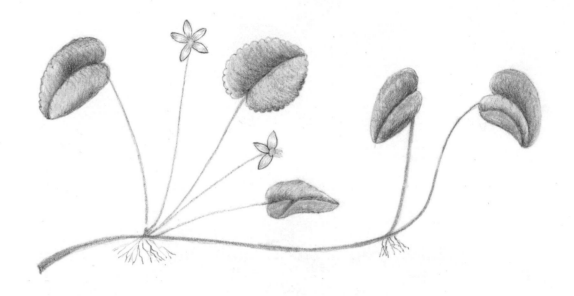

Order Rosaceae.
Dalibarda repens.

False Violet.

Low herbs. Stems creeping. In woods, Can. to Penn.
June.

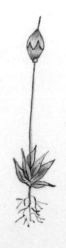

Physcomitrium pyriforme.

On the ground; extremely common.

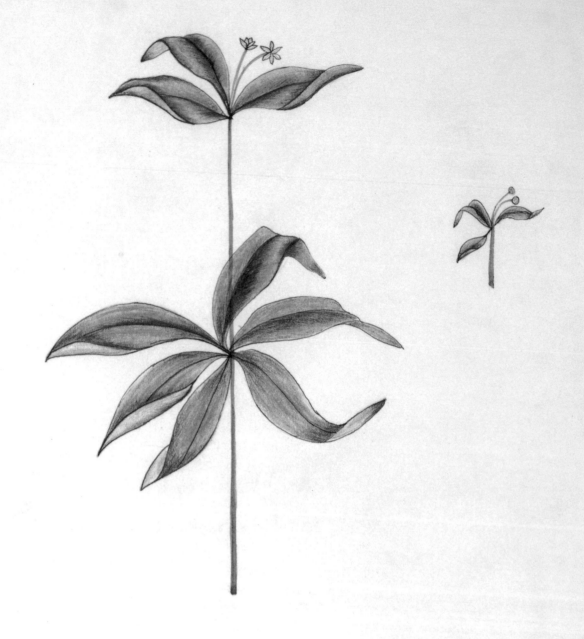

Order Trilliaceae.
Medeola Virginica.
Indian Cucumber root.
Found in the woods. None can but ad—
mire the symetry of its form.

July.

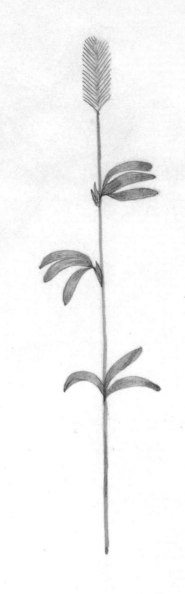

Order Leguminosae.
Trifolium arvense.
Hare's foot Trefoil.
A low plant in dry sandy fields.
Me. to Fla. Heads of pale red flowers.
July. Aug.

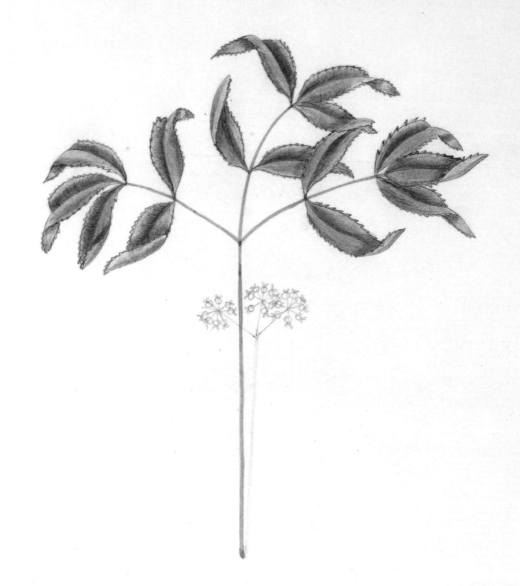

Order Araliaceae.

Aralia nudicaulis.

Wild Sarsaparilla.

A well known plant, found in woods.
Most abundant in rich and rocky soils, Can.
to Car. It has a leaf stalk, but no proper stem.
June, July.

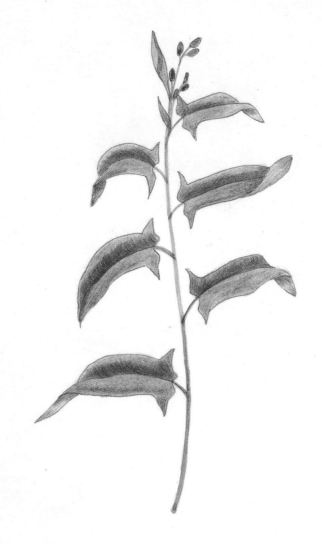

Order Polygonaceae.
Polygonum arifolium.
Hastate Knotgrass.
Found in wet grounds. Can. to Ga.
It has very large halbert shaped leaves.
June, July.

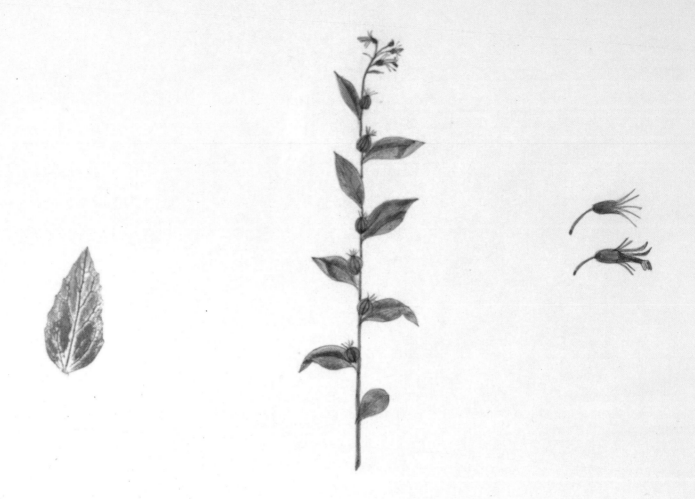

Order Lobeliaceae.

Lobelia inflata.

Indian tobacco.

In fields and woods. Can. and U.S.
The species of Lobelia are more or less poisonous.
The milky juice is narcotic, producing effects
similar to those of tobacco.

July. Sept.

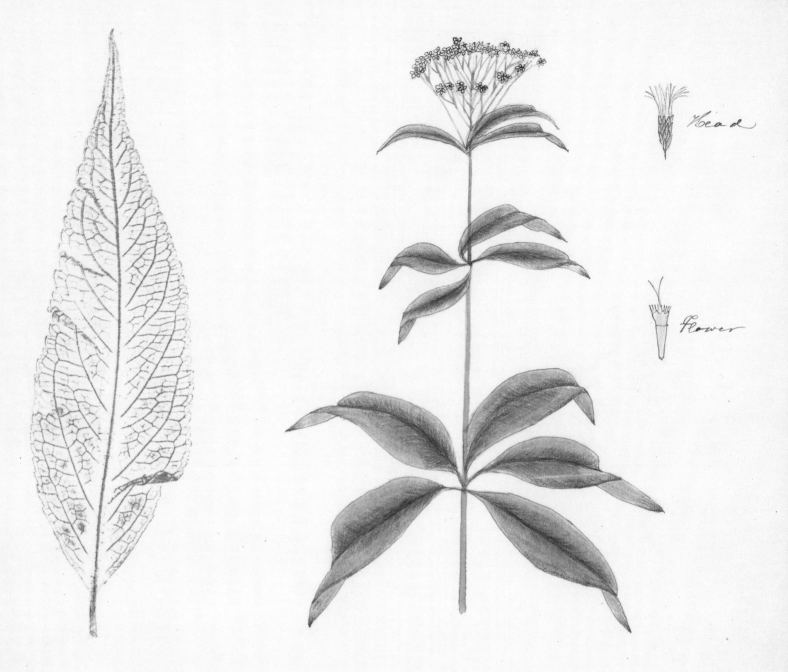

Head

flower

Order Compositae.
Eupatorium purpureum.

Dry fields and woods, common. Stem 3 to 6 ft
high.

Aug. Sept.

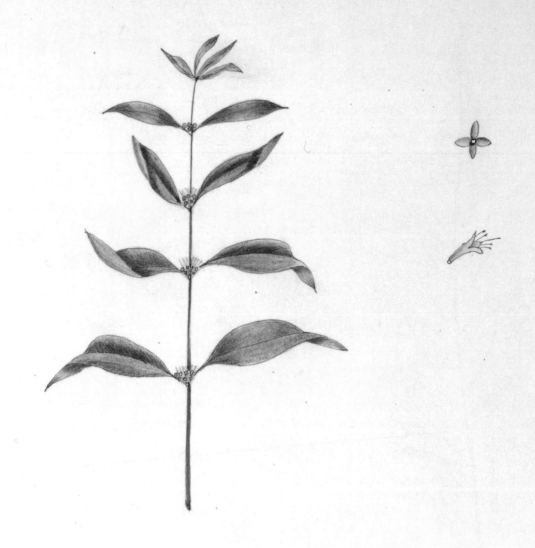

Order Labiatae.
Mentha Canadensis.

Horsemint.

An herbaceous, grayish plant, 1 to 2 ft.
high, growing in muddy situations, Can. to
Ky. Aromatic like pennyroyal, but less so.

June, July.

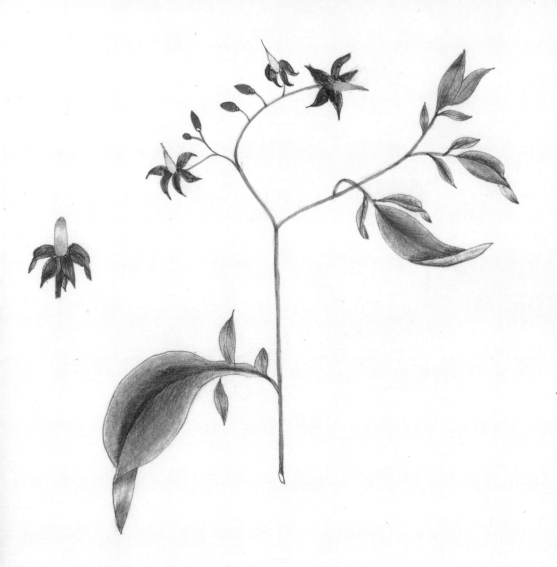

Order Solanaceae.

Solanum dulcamara.

Bittersweet. Nightshade.

A well known climber, with blue
flowers and red berries, N. Eng. to Ark.
The berries are said to be poisonous.

July.

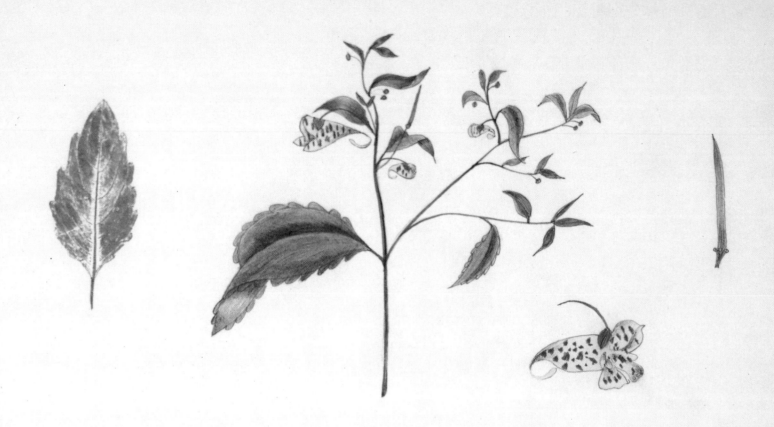

Order Balsaminaceae.
Impatiens fulva.
Touch me not. Jewel weed.
In wet grounds, Can. to Ga. Capsule
1in long, bursting at the slightest touch when
mature and scattering the seeds.
Aug.

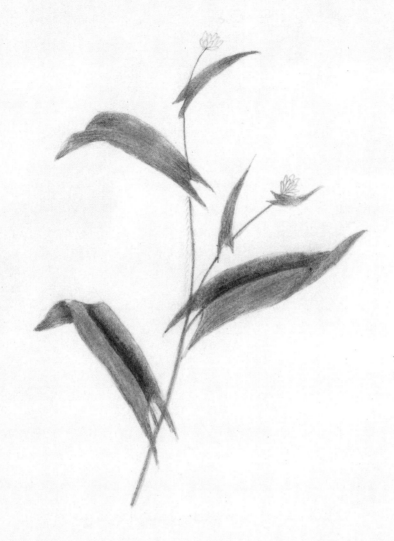

Order Polygonaceae.
Polygonum sagittatum.

Scratch Grass.

 In wet grounds. Can. and U.S. A rough
climbing species. 2 to 5 ft in length.
Flowers white. June.

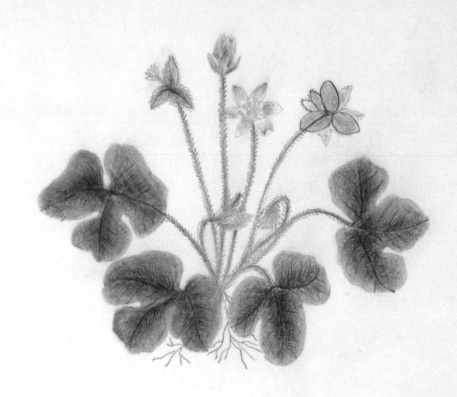

Order Ranunculaceae.
Hepatica triloba.

Liverwort.

This little plant is one of the earliest
harbingers of the spring, often putting forth
its neat and elegant flowers in the neighborhood
of some lingering snow bank. Found in the
woods from Can. to Ga, and west to Wis.

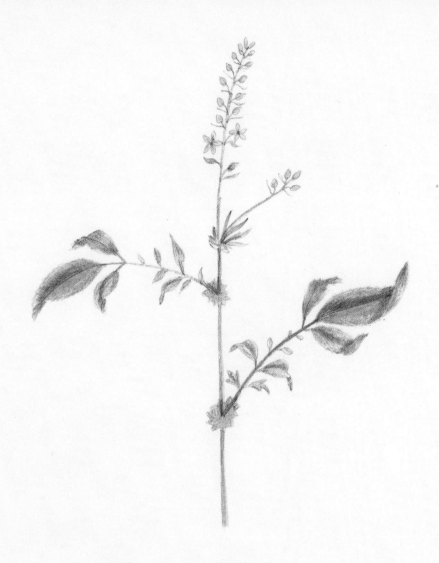

Order Rosaceae.
Agrimonia Eupatoria.
Agrimony.
Found by the road sides and borders of
fields, Can. and U. S. common.
July.

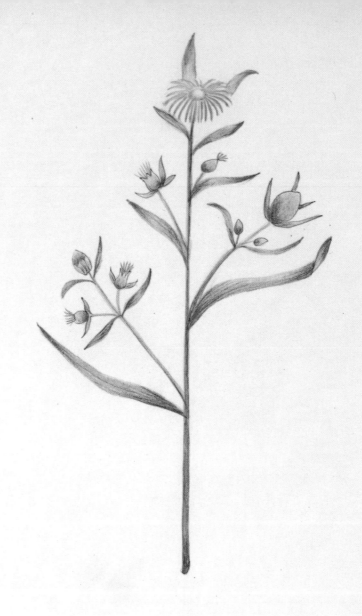

Order Compositae.
Aster puniceus.

Aster.

A large, aster, common in swamps, & ditches &
sometimes in dry soils. Northern States & Canada.

Aug & Sept.

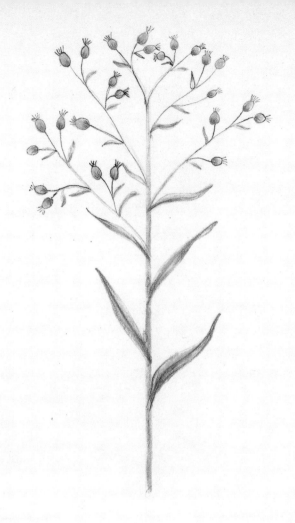

Order Compositae.
Aster Multiflorus.

Aster.

A very bushy aster, with numerous small flowers.
Rocks and dry fields. U.S. Variable.

Sept.

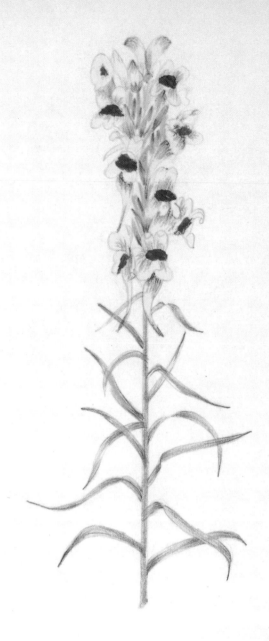

Order Scrophulariceae.
Linaria vulgaris.
Common Toad Flax.

A very showy plant, common by road sides, N. Eng to Ky and Ga. 1 to 2 ft high, very leafy.
July, Aug.

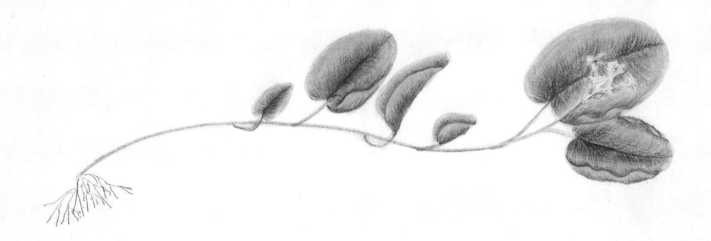

Order Ericaceae.

Epigaea repens.

Trailing arbutus. May Flower.

Found in the woods from Newfoundland
to Ky. A little shrubby plant, grows flat on
the ground. Flowers are very fragrant.

Apr. May.

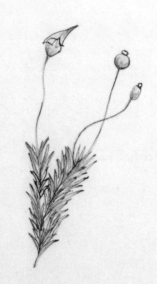

Bartramia pomiformis.

Apple moss.

On shady banks, either dry or moist,
common.

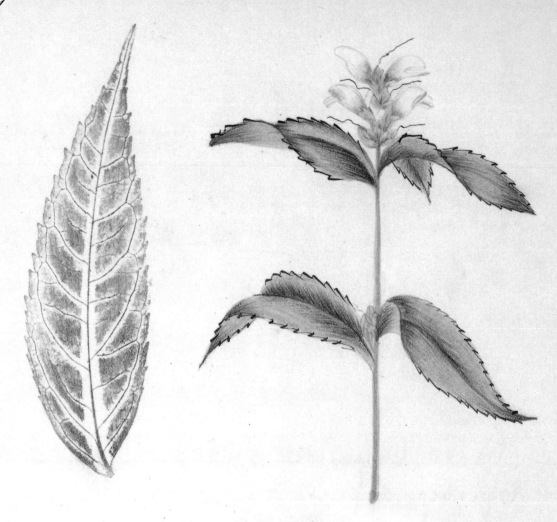

Order Scrophulariaceae.
Chelone glabra.
Snake head. Turtle head.
A plant of brooks and wet places.
Can. and U. S. with flowers shaped like
the head of a snake, the mouth open and
tongue extended. Aug. Sept.

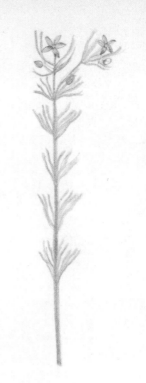

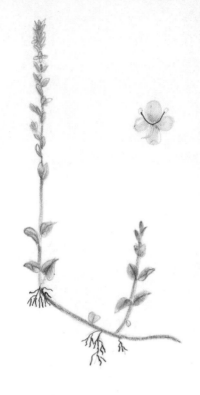

Order Caryophyllaceae.

Spergularia rubra.

Red sand wort.

Sandy fields. Can. to Flor.

Stem a few inches high. slender.

May. Oct.

Order Scrophulariaceae.

Veronica serpyllifolia.

Speed well.

In meadows, valleys and in

grass by the road side. U. S. & Can.

May. Aug.

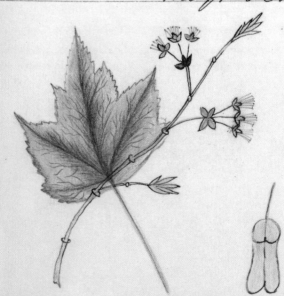

Order Aceraceae.

Acer rubrum.

Red Maple.

Common in the woods of N. E.

Flowers are crimson.

Apr.

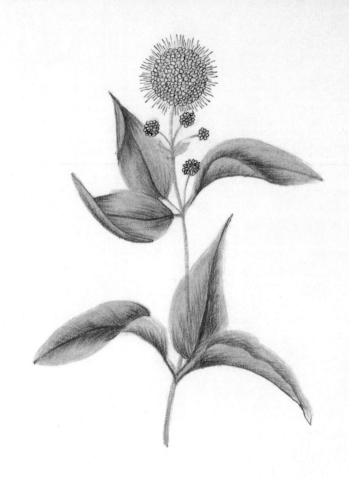

Order Rubiaceae.

Cephalanthus. occidentalis.

Button Bush.

Readily distinguished by its spherical
heads of flowers. A handsome shrub, frequent-
ing the margins of rivers, ponds and brooks, U.S.
and Can. Height, 6 ft.

July.

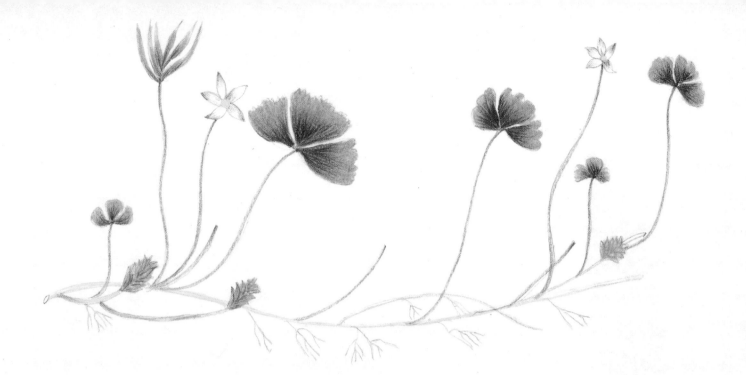

Order Ranunculaceae.
Coptis trifolia.
Gold thread.

Found from Arctic Amer to Penn. in shady woods. Stem creeping. golden yellow, very bitter. Peduncle bears a single, white star like flower.

May.

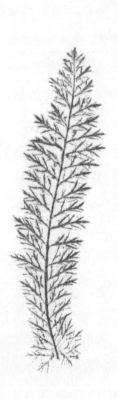

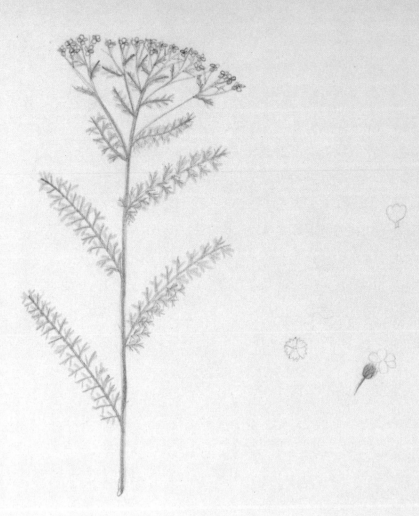

Order Compositae.
Achillea millefolium.
Millfoil. Yarrow.

In fields and pastures, N. E. to Or and
to the Arctic Sea. Flowers are white or rose colored.
July, Sept.

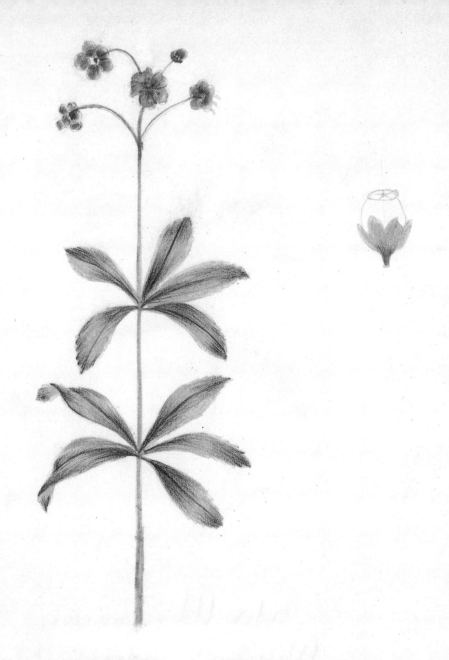

Order Ericaceae.

Chimaphila umbellata.

Prince's Pine.

A common little evergreen in Can. and U.S. Found in the woods. Used in medicine.

July.

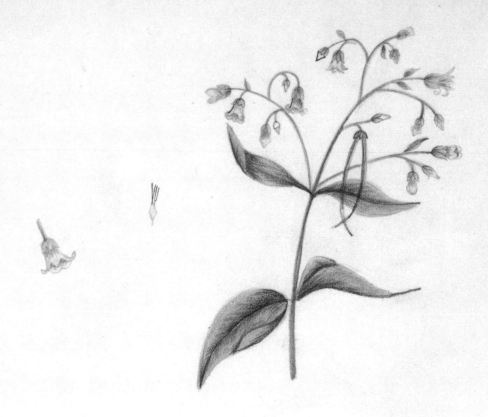

Order Apocynaceae,
Apocynum androsaemifolium.

Dog's Bane.

A smooth, elegant plant, 3 ft high. in hedges and borders of fields. Stem reddened by the sun. erect. branching above. Medicinal.

June. July.

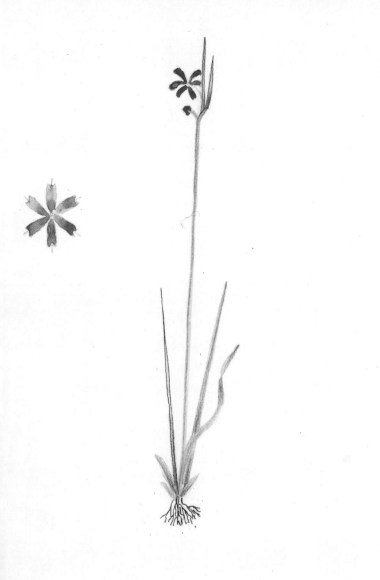

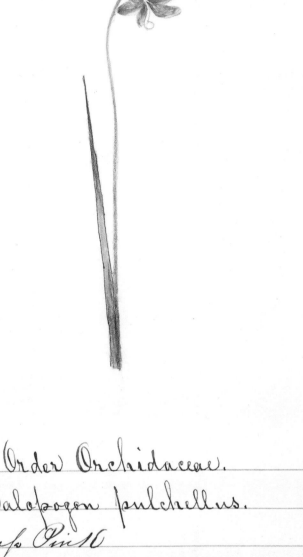

Order Iridaceae.

Sisyrinchium Bermudianum.

Blue eyed grass.

A delicate little plant,
with blue flowers, common in
low grass lands, Can & U.S.

June. July.

Order Orchidaceae.

Calopogon pulchellus.

Grass Pink

A beautiful plant, in swamps
and damp meadows, Can. &
U.S. 10 to 20 inches high.

June. July.

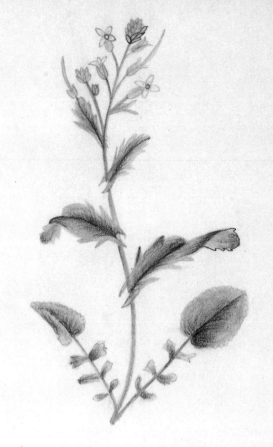

Order Cruciferae.
Barbarea vulgaris.

Winter Crefs.
Fields & brooksides, common in Northern States.
May & June.

Order Lycopodiaceae.
Lycopodium dendroideum.
Club Moss.
Common in woods, & readily distinguished
by its upright, tree like form.
July.

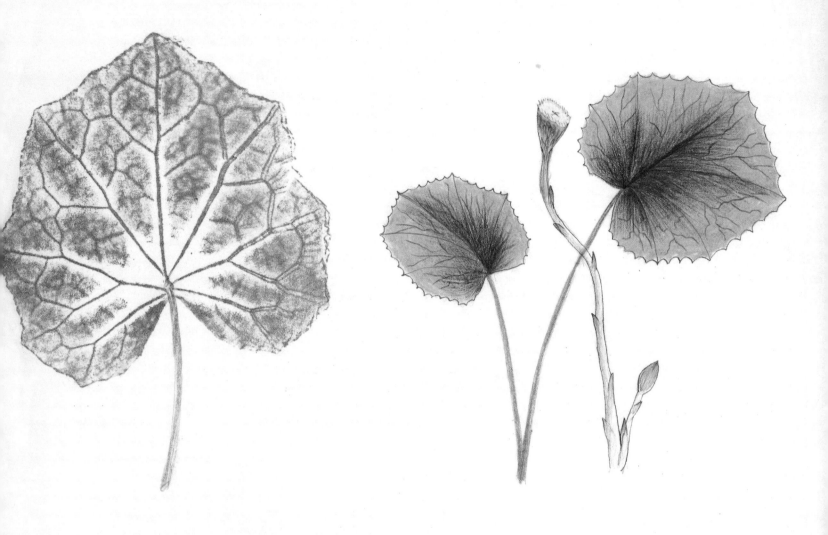

Order Compositae.
Tussilago. farfara.

Colts' foot.

In wet places, brookbrides & on the shores of lakes. North and
middle states. It grows in clayey soil. The flower appears in
early spring before a leaf is to be seen.

Order Ranunculaceae.

Ranunculus reptans.

Creeping Crowfoot.

On river banks and other wet places. Can & N.H. & West.

July.

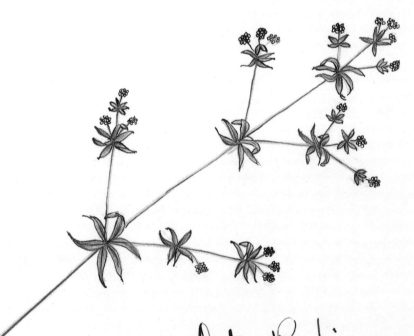

Order Rubiaceae.

Galium asprellum.

Rough Cleavers.

Common in thickets and low grounds. Can. and U.S.

July.

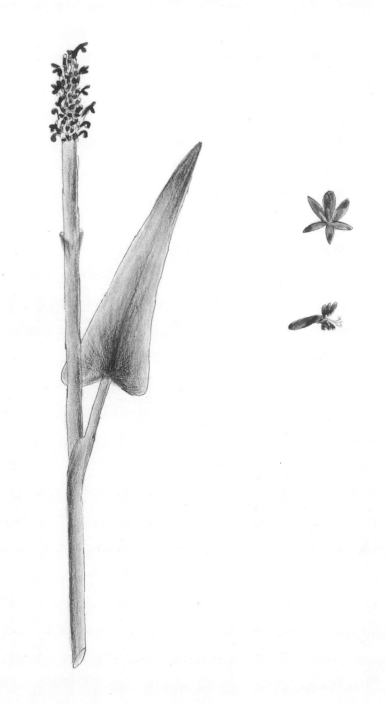

Order Pontederiaceae.
Pontederia cordata.

Pickerel Weed.
A fine conspicuous plant, native of the
borders of muddy lakes, and rivulets, growing in
patches, extending from the shore to deep water.
July.

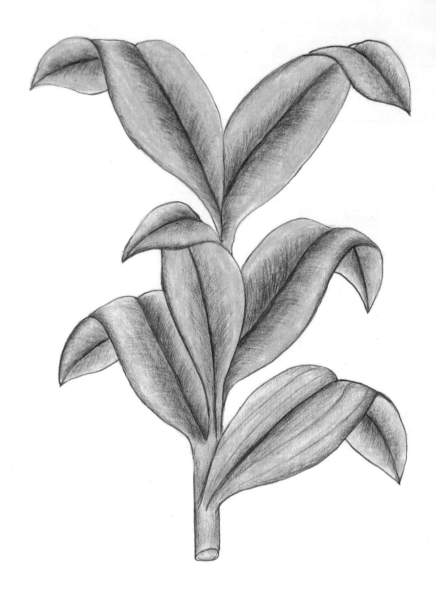

Order Melanthaceae.
Veratrum viride.

False Hellebore.

A large. coarse looking plant, of our meadows + swamps.
Can. to Ga. Root, emetic and stimulant, but poisonous.

July.

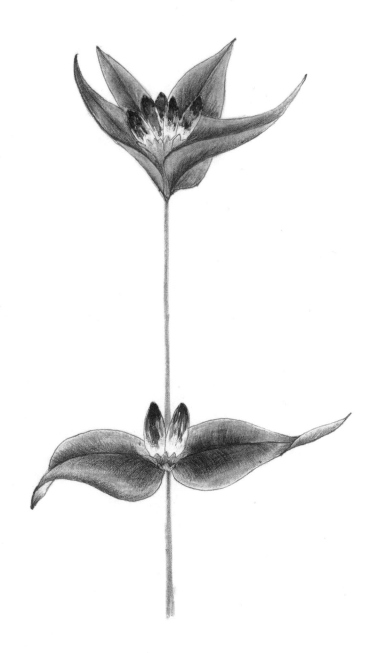

Order Gentianaceae.
Gentiana Andrewsii.
Closed Blue Gentian.
 A handsome plant, conspicuous in
meadows and by brooksides, British Amer.
to Car. 12 to 18 in high. Sept. Oct.

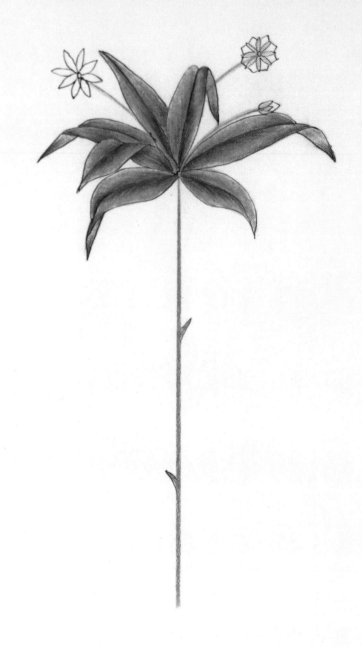

Order Primulaceae.

Trientalis Americana.

Chickweed Wintergreen.

Common in rocky woods of Can. to Ga.

May. June.

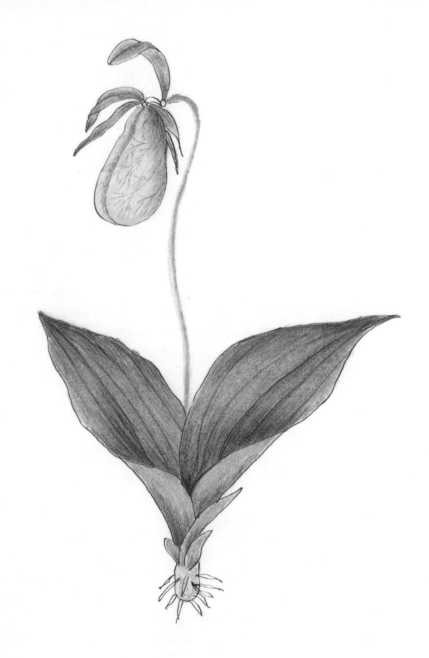

Order Orchidaceae.
Cypripedium acaule.

Lady's Slipper.
In dark woods, Car. to Arc. Amer.

May. June.

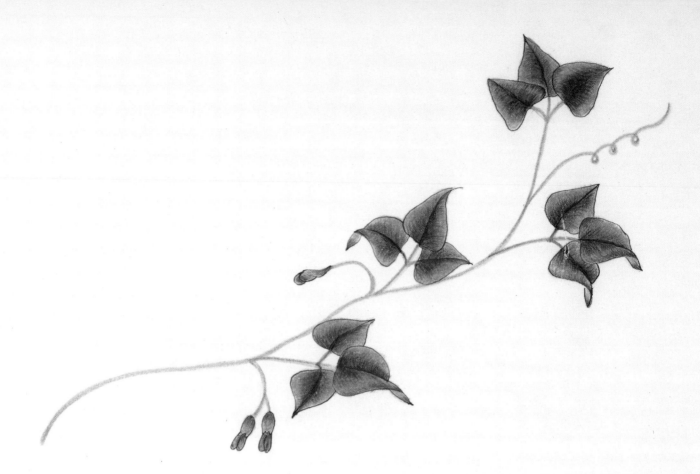

Order Leguminosæ.
Amphicarpæa. monoica.

Pea vine

A very slender vine in woods & thickets, Can. & U.S.
July. Sept.

Mnium cuspidatum.

In woods and about the roots of trees:

common.

71

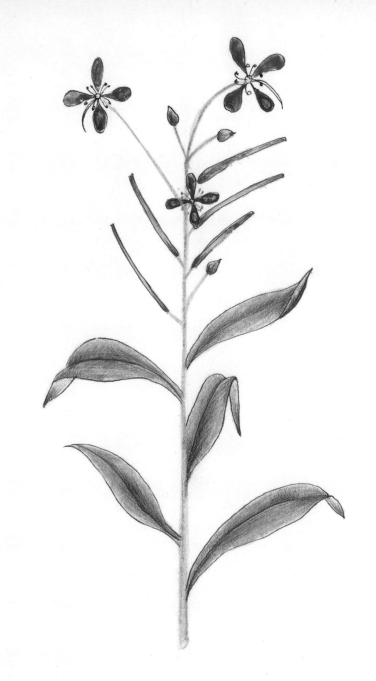

Order Onagraceae.
Epilobium angustifolium.

Rose Bay.

In newly cleared lands, low waste grounds. Penn.
to Are. America.
July: August.

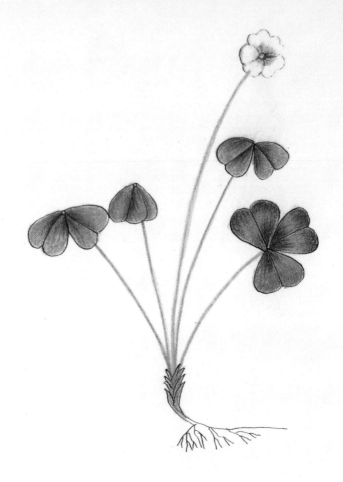

Order Oxalidaceae.
Oxalis Acetosella.

Wood Sorrel.

Woods & shady places, Can. & U.S.

June.

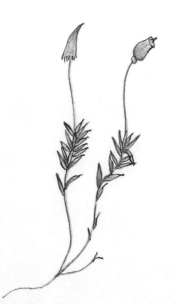

Polytrichum commune.

Hair cap moss.

Shady places, common. Plant 6' high

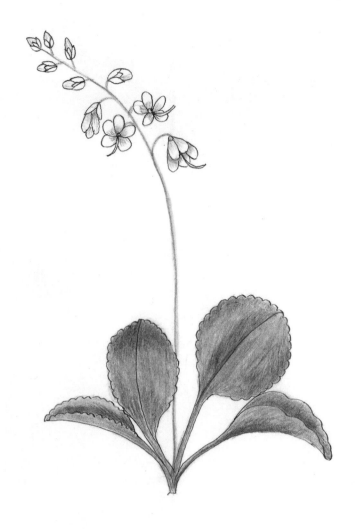

Order Ericaceae.

Pyrola chlorantha.

Wintergreen.

In woods, Can. and Northern States, common.

June, July.

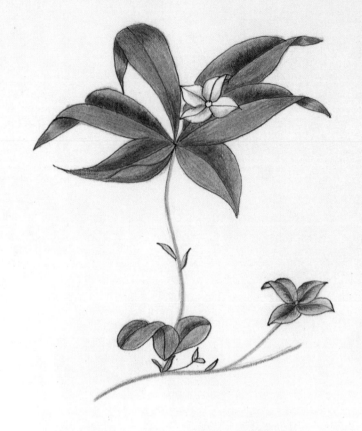

Order Cornaceae.

Cornus Canadensis.

Low Cornel. Bunch plums.

 A small, pretty plant in woods, nearly throughout North America.

 May. June.

Cladonia coccinea.

Cup Lichen.

 Grows on pieces of bark or old trees, that lay on the ground.

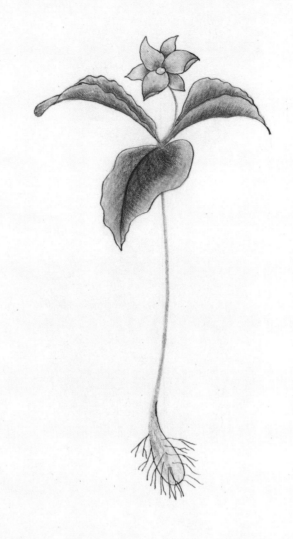

Order Trilliaceae.

Trillium erectum.

Bath flower.

A conspicuous plant in woods, of fine appearance.

but offensive odor.

May.

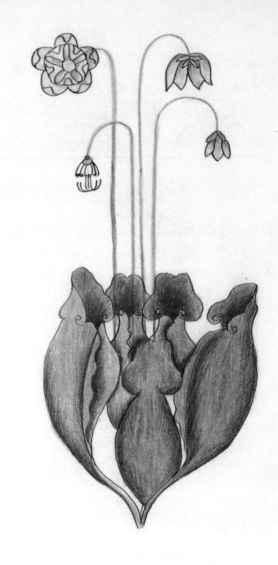

Order Sarraceniaceae.
Sarracenia purpurea.

Pitcher plant.

In bogs & wet meadows throughout Can. & U.S.

June.

Notebook Two

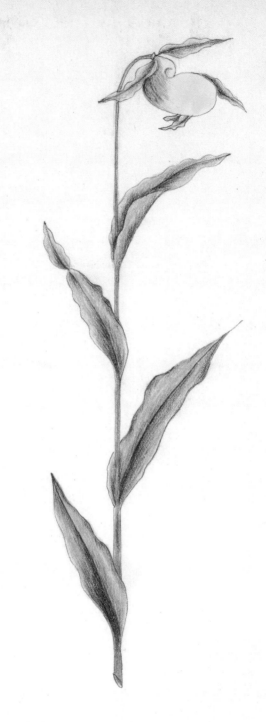

Order Orchidaceae.

Cypripedium pubescens.

Yellow Slipper.

 Woods and meadows. Can. to Wis. and south to Georgia.

 May—June.

2

Order Ericaceae.
Chiogenes hispidula.

Boxberry.

In old woods & on mountains.
N.E. to Newfoundland.

May - June.

Order Taxaceae.
Taxus Canadensis.
Ground Hemlock.

A small evergreen shrub. It
grows on thin rocky soil in shady
places, Can. to Ky.

May.

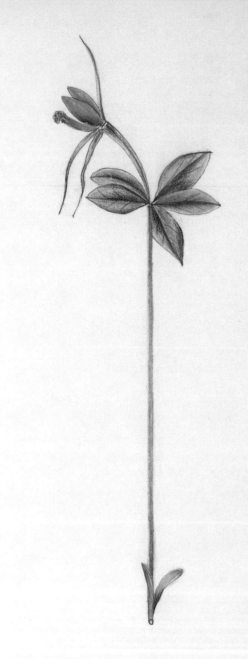

Order Orchidaceae.
Pogonia verticillata.

Swamps. Can to Ga. common.

July.

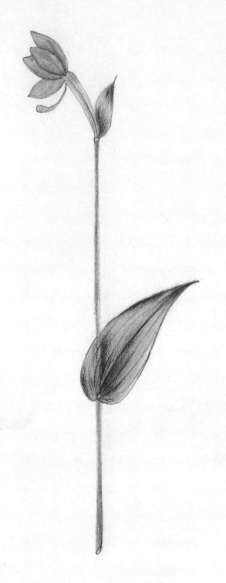

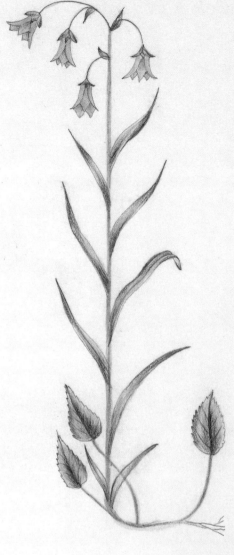

Order Orchidaceae.

Pogonia ophioglossoides.

In swamps and on muddy

shores. Can. N. Eng. to Car and Ky.

June.

Order Campanulaceae.

Campanula rotundifolia.

Hare bell.

On damp rocks. rocky streams

Northern States & Brit. Amer.

June — July.

4

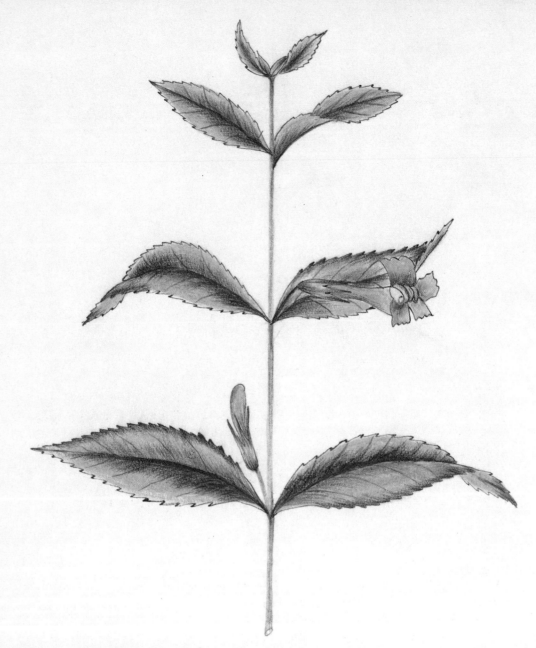

Order Scrophulariaceae.
Mimulus ringens.

Monkey flower.
 A common inhabitant of ditches & muddy soils.
Can. and U.S.
 July – Aug.

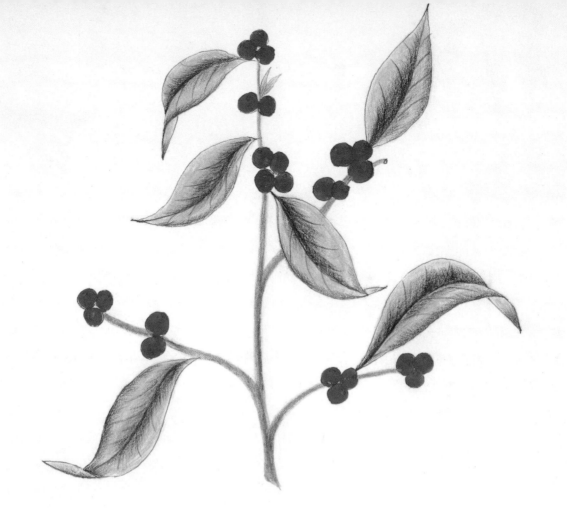

Order Aquifoliaceae.
Prinos verticillatus.

Winter berry.

Found in moist woods or swamps. Can & M.S.

July.

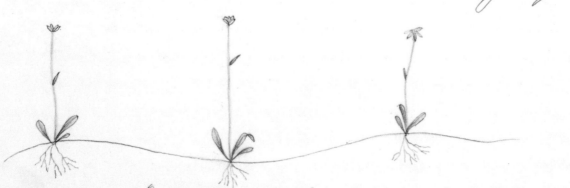

Order Ranunculaceae.

Ranunculus reptans.

Creeping Crowfoot. On river banks & other wet places, Can & N.H. & West July.

6

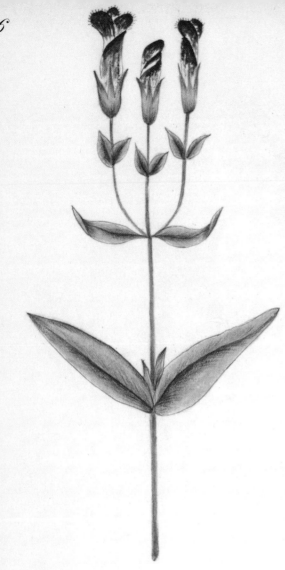

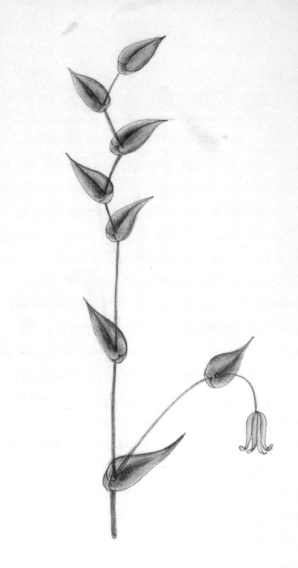

Order Gentianaceae.

Gentiana crinita.

Blue fringed Gentian.

Not uncommon in cool, low
grounds. Can. to Car.

August.

Order Liliaceae.

Uvularia perfoliata.

Mealy Bellwort.

A handsome plant in the
woods. Can. & U. S.

May.

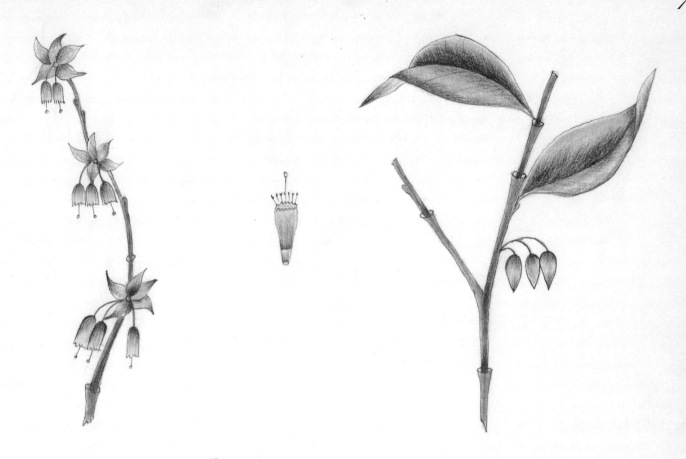

Order Thymelaceae.
Dirca palustris.

Leather Wood. Grows near mountain streams & rivulets. M.S. & Can. Every
part of the shrub is very tough. Apr. May.

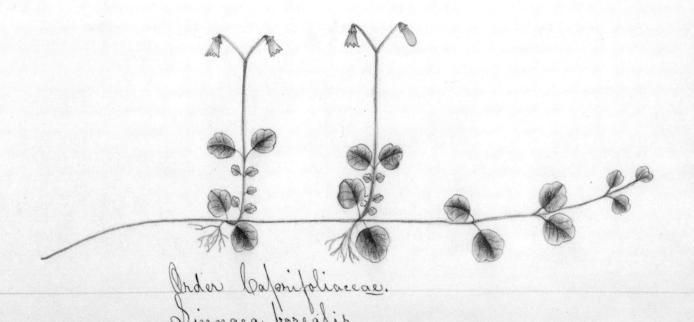

Order Caprifoliaceae.
Linnaea borealis.

Twin flower. Moist soils in evergreen woods, from lat 39° to Arc Sea. June.

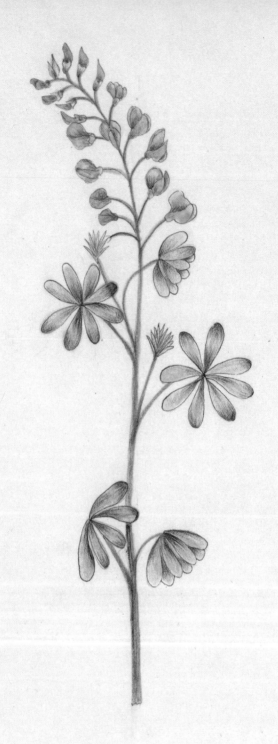

Order Leguminosae.
Lupinus perennis.

Lupine.

A beautiful plant. In sandy woods, & hills. Can. to Fla.
ℋ Turning to face the sun, from morning till night.

May. June.

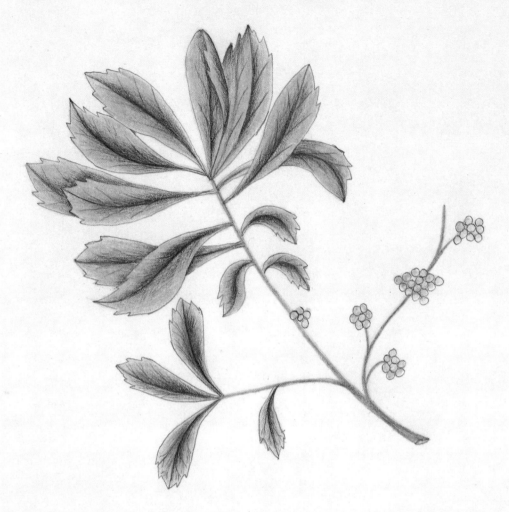

Order Myricaceae.
Myrica cerifera.

Bayberry.
Found in dry woods, or in open fields, Can to Fla.
May.

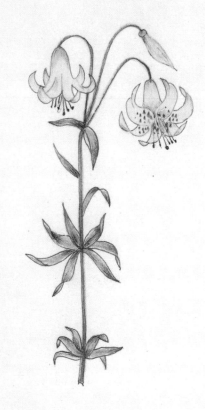

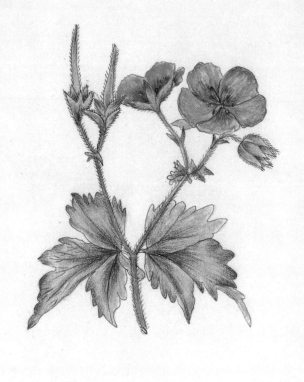

Order Liliaceae.

Lilium Canadense.

Yellow lily.

Found in meadows & wet places.

Can. & U.S. July.

Order Geraniaceae.

Geranium maculatum

Spotted Geranium.

In dry rocky places. Can to Va & Ky.

May — Sept.

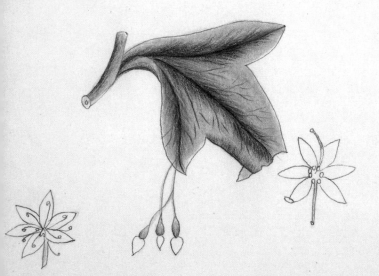

Order Lauraceae.

Sassafras officinale.

Sassafras.

Grows in the U.S. & Can. Every
part of the tree has a pleasant fragrance
& an aromatic taste.

Apr. June.

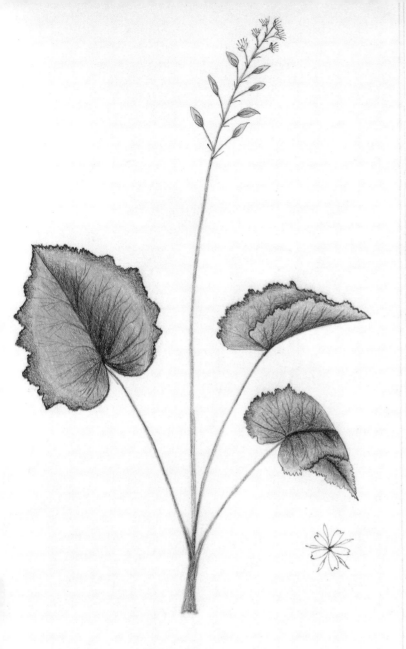

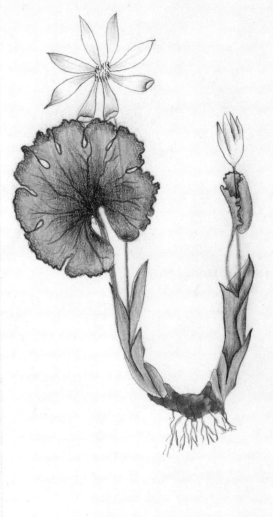

Order Saxifragaceae.

Tiarella cordifolia.

Bishop's Cap.

In rocky woods, Can. to Ga. Common in N. Eng.

Order Papaveraceae.

Sanguinaria Canadensis.

Blood root.

In woods. Can. & U.S. When bruised the plant exudes an orange red fluid. The juice is emetic & purgative.

Apr. May.

12

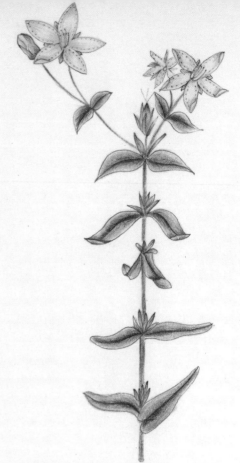

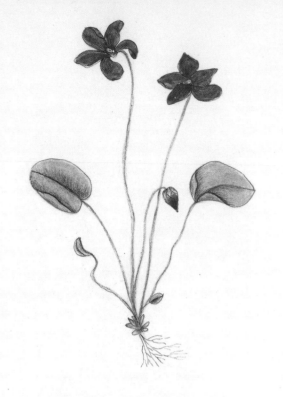

Order Hypericaceae.
Hypericum perforatum.
St Johns Wort.
In dry pastures, Can. & U.S.
June, July.

Order Violaceae.
Viola canina
Violet. A slender species in swamps.
U.S. to Lab. May.

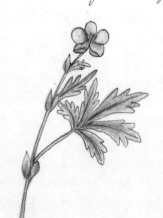

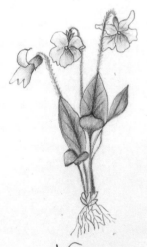

Order Rosaceae.
Potentilla anserina.
Silver weed. On wet shores and
meadows. N.E. to Arc. Am.
June to Sept.

Order Violaceae.
Viola cucullata.
Violet. A common violet, found in grassy
woods from Arctic Am to Florida.
Apr. May.

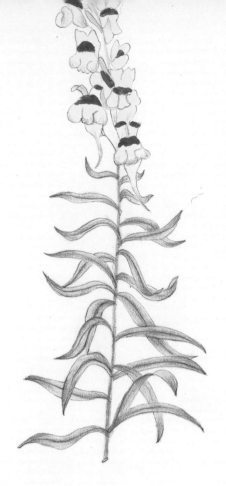

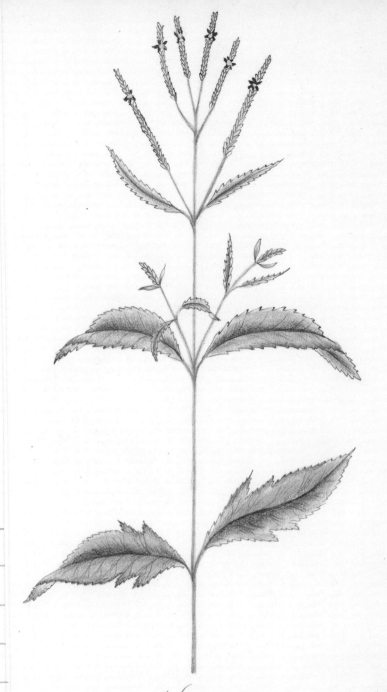

Order Scrophulariaceae.
Linaria vulgaris.

Toad flax.

A very showy plant, common by
road sides. N.E. to Ky & Ga.

July. Aug.

Order Coniferae.
Larix Americana.

Larch. Tamarack.

A beautiful in forests from
Can to Penn. Apr. May.

Order Verbenaceae.
Verbena hastata.

Vervain.

Frequently by roadsides & in low
grounds, mostly throughout the U.S.
& Can.

July, Sept.

14

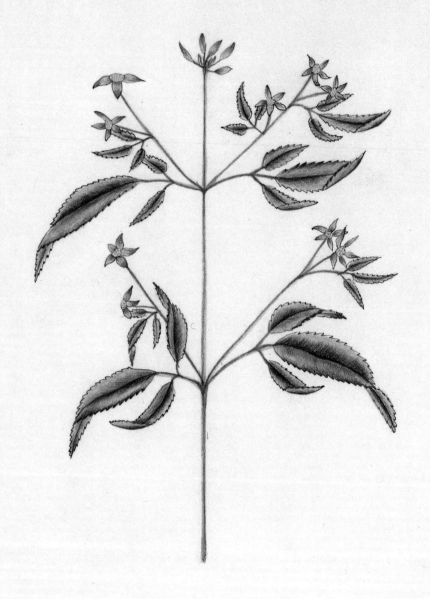

Order Compositae.
Bidens frondosa.

Leafy Burr Marigold.
Fields and hedges. Can. to Ga.

July. Sept.

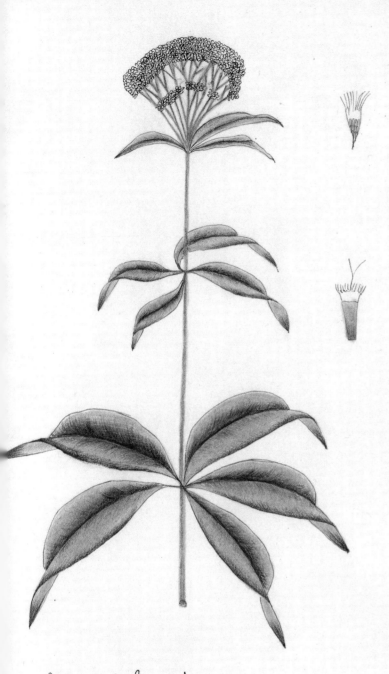

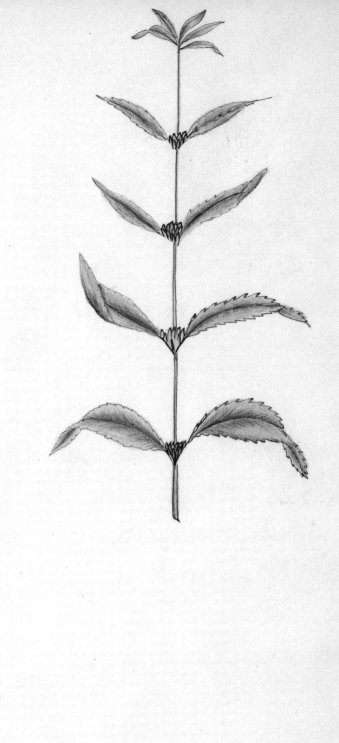

Order Compositae.

Eupatorium purpureum.

Dry Fields & woods, common. Stem 3 to 6 ft.

Aug. Sept.

Order Labiatae.

Mentha Canadensis.

Horsemint.

An herbaceous plant growing
in muddy situations. Can to Ky.
Stem square. Aromatic.

June & July.

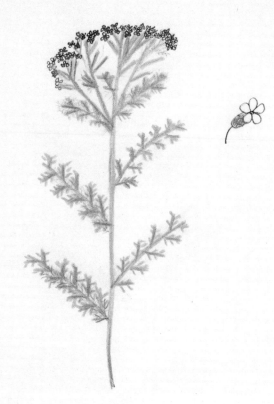

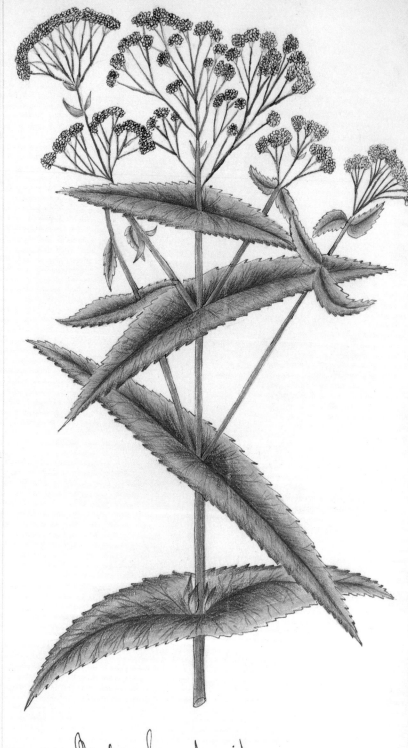

Order Compositae.

Achilla millefolium.

Millfoil. Yarrow.

In fields & pastures. N.E. to Or

and to the Arctic Sea.

July. Sept.

Order Compositae.

Eupatorium perfoliatum.

Thoroughwort

A common plant, on low grounds

meadows. U.S. & Can. abundant. The

plant is bitter & used in medicine.

Aug.

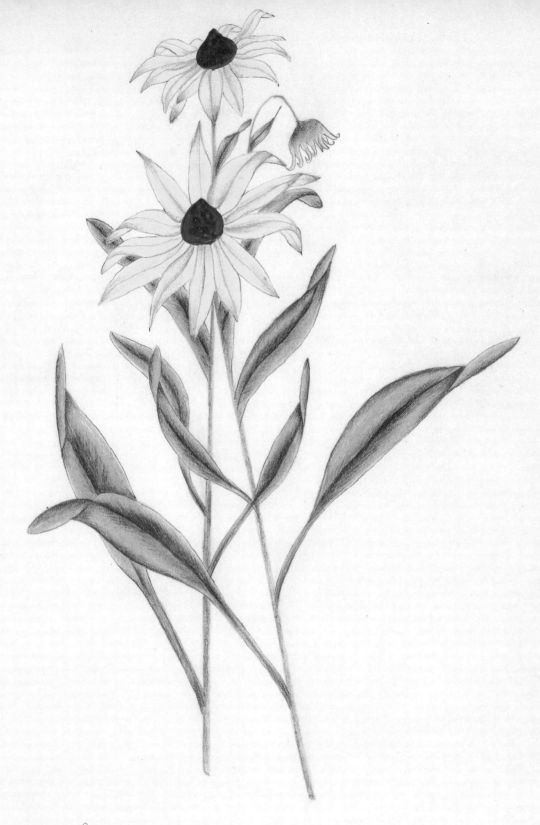

Order Compositae.
Rudbeckia laciniata.

Cone Flower.
In the edges of swamps & ditches, Can. & M.S.
Aug.

18

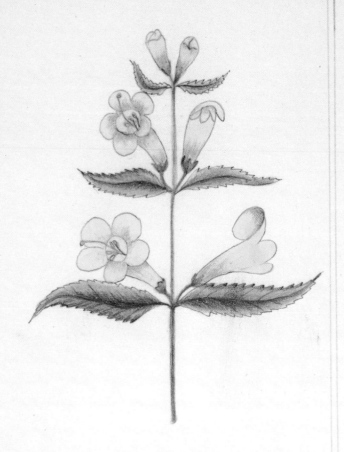

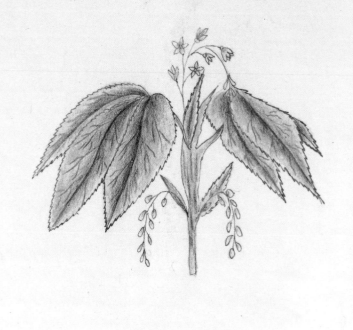

Order Scrophulariaceae.
Dasystoma flava.
Yellow Fox glove.
A showy plant 2 to 4 ft. high.
in woods throughout the U.S.
Aug, Sept.

Order Aceraceae.
Acer Pennsylvanicum.
Striped Maple.
A small tree 10 or 15 ft high. In woods.
May.

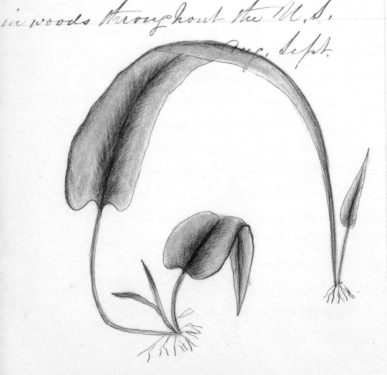

Order Filices.
Antigramma rhizophylla.
Walking Fern.
This singular fern grows in
rocky woods. not very common.
July.

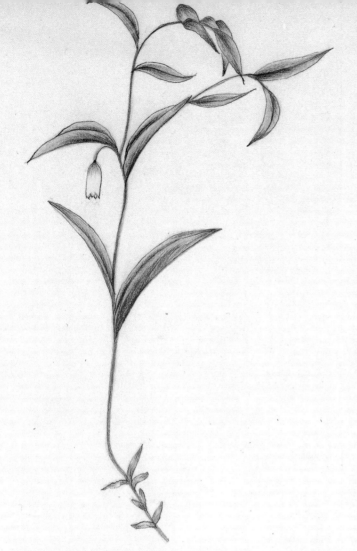

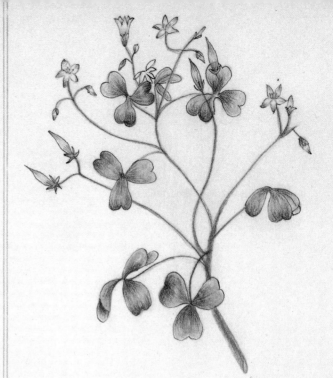

Order Liliaceae.

Uvularia sessilifolia.

Wild Oats.

Found in woods & in grass lands, Can.
U.S. May.

Order Musci.

Physcomitrium pyriforme.

On the ground, ex-
tremely common.

Order Oxaliaceae.

Oxalis stricta.

Wood Sorrel.

Fields. U.S. & Can. common. Flow-
ers small, appearing all summer.

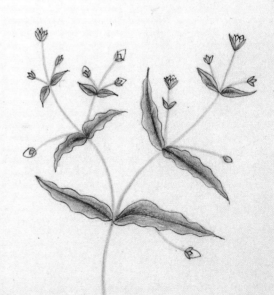

Order Caryophyllaceae.

Stellaria media.

Chickweed. A common weed. flow-
ering from early spring till Autumn.

20

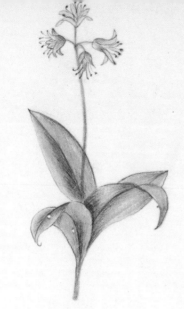

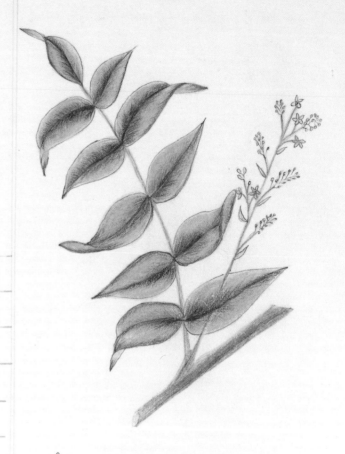

Order Liliaceae.
Clintonia borealis.
Northern Clintonia.
Mountainous or hilly woods,
Can. to Car. & west to the Miss.
May. June.

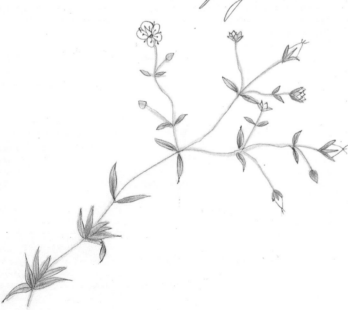

Order Caryophyllaceae.
Alsine stricta.
Sandwort.
Sterile grounds, Arc. Amer to Ga.
May. June.

Order Anacardiaceae.
Rhus venenata.
Poison Sumac.
A shrub of fine appearance.
10 to 15 ft high, in swamps, U. S. &
Can. Flowers very small and
green. The whole plant is poi-
sonous to the taste or touch.
June.

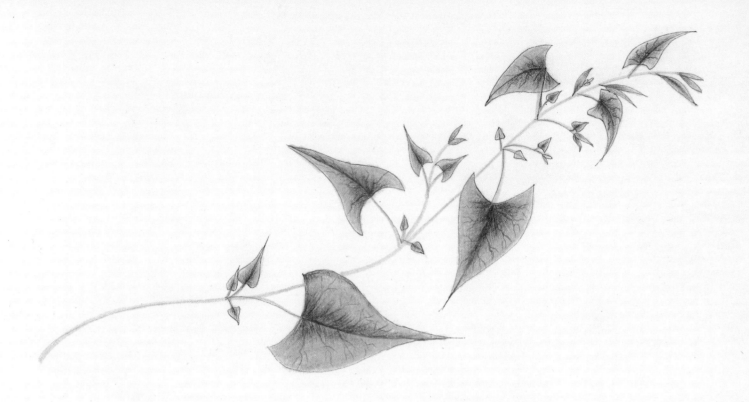

Order Polygonaceae.
Polygonum dumetorum.
Hedge Bindweed.
Thickets, Can. & M.S. Climbing over bushes.
July & Sept.

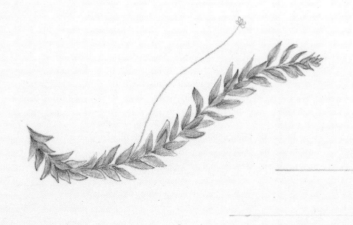

Order Hydrocharidaceae.
Anacharis Canadensis.

Ditch Moss,
In still waters and bogs.

Aug.

22

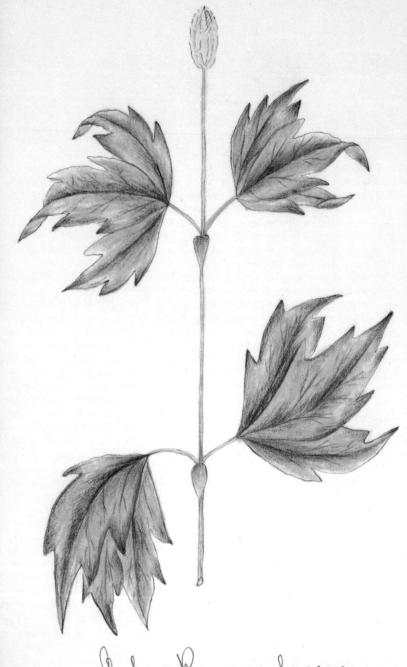
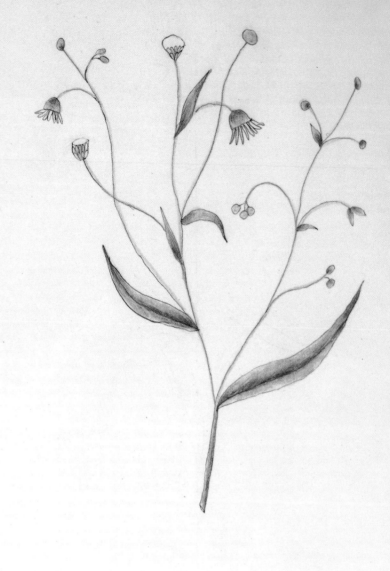

Order Ranunculaceae.

Ranunculus Pennsylvanicus.

A very hairy species in wet grounds.
Can & U.S.
　　　　　　　June.

Order Compositae.

Erigeron Philadelphicum.

White Weed.

Woods and pastures throughout
North America.
　　　　　　　June to Aug.

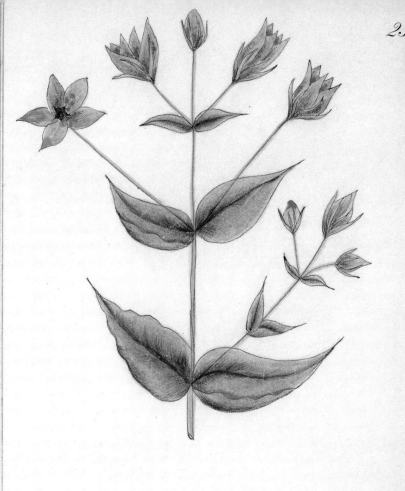

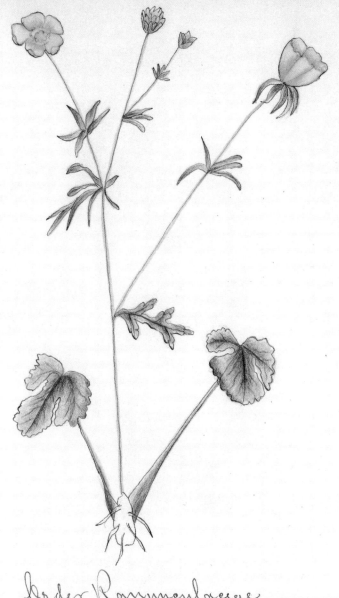

Order Ranunculaceae.

Ranunculus bulbosus.

Buttercups.

Common in pastures & mow lands.
An acrid species.

May.

Order Gentianaceae.

Sabbatia angularis.

Wet meadows & prairies. Can. to
Car & Ark.

July & Aug.

Order Musci.

Bartramia pomiformis

Apple moss.

On shady banks. either
dry or moist. common.

24

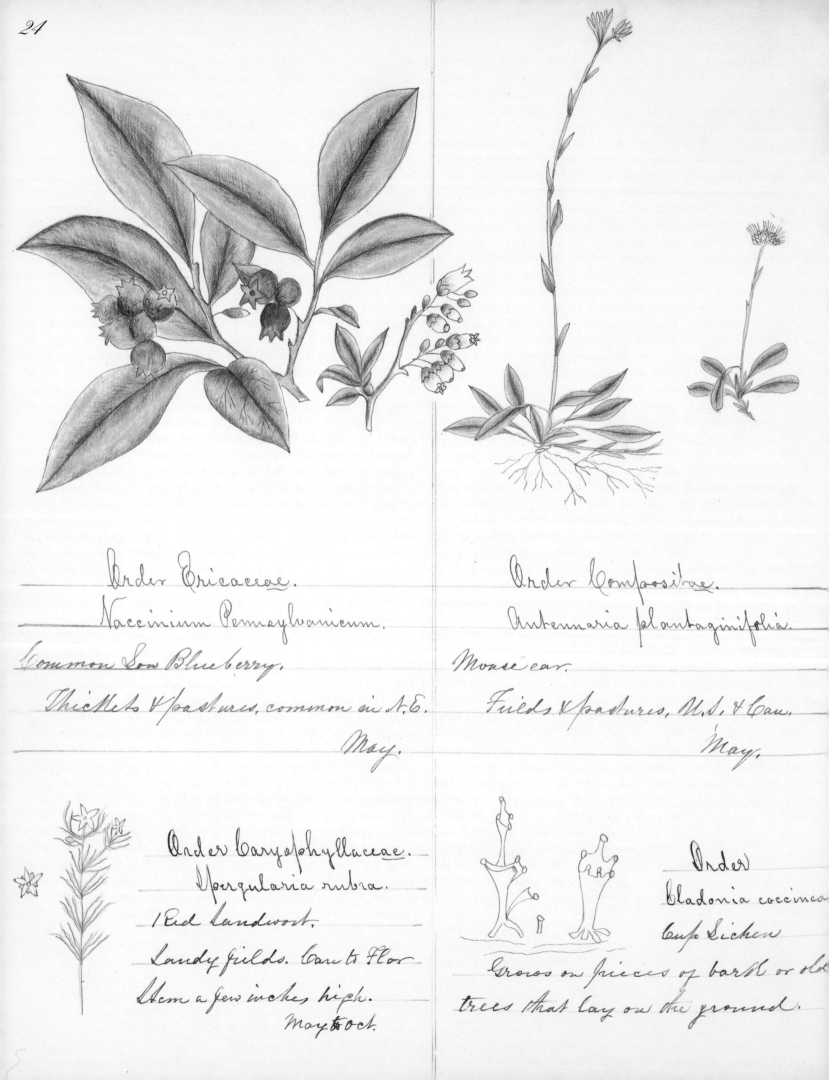

Order Ericaceae.
Vaccinium Pennsylvanicum.
Common Low Blueberry.
Thickets & pastures, common in N.E.
May.

Order Compositae.
Antennaria plantaginifolia.
Mouse ear.
Fields & pastures, U.S. & Can.
May.

Order Caryophyllaceae.
Spergularia rubra.
Red Sandwort.
Sandy fields. Can to Flor
Stem a few inches high.
May to Oct.

Order
Cladonia coccinea
Cup Lichen
Grows on pieces of bark or old
trees that lay on the ground.

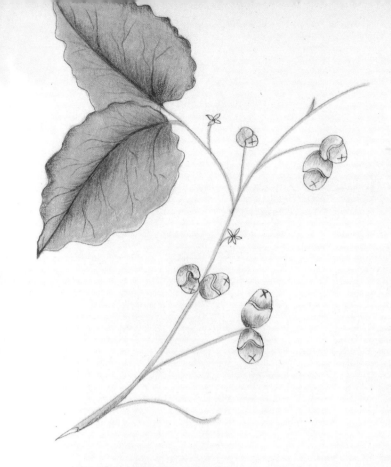

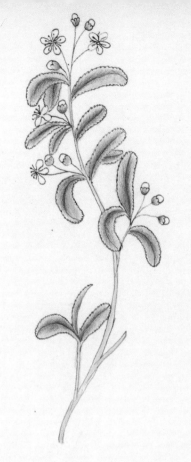

Order Hamamelaceae.
Hamamelis Virginiana.
Witch Hazel.
 A large shrub consisting of
several crooked, branching trunks
from the same root. U.S. & Can.
 Nov. Jan.

Order Rosaceae.
Amelanchier Canadensis.
Shad berry. June Berry.
 A small tree in woods. U.S. & Can
Flowers appear in early spring.

Order Aceraceae.
Acer rubrum.
Red Maple.
 Common in woods of N.E.
Flowers are crimson.
 Apr

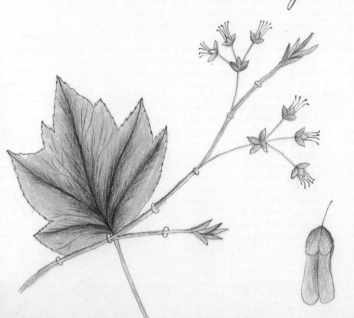

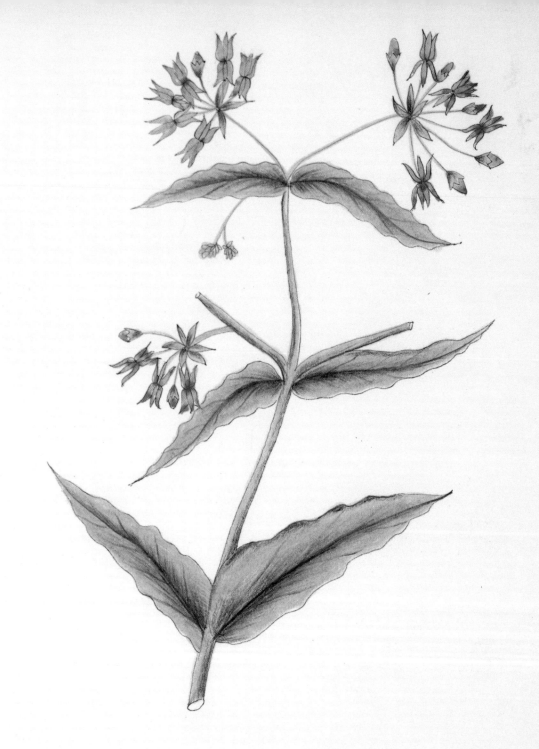

Order Asclepiadaceae.

Asclepias tuberosa.

Butterfly Weed.

Dry fields, Can. & U.S. A medicinal plant.

Aug.

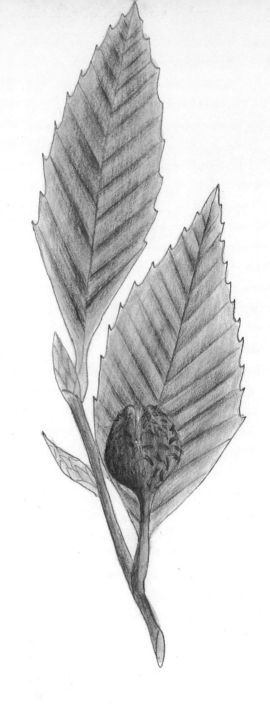

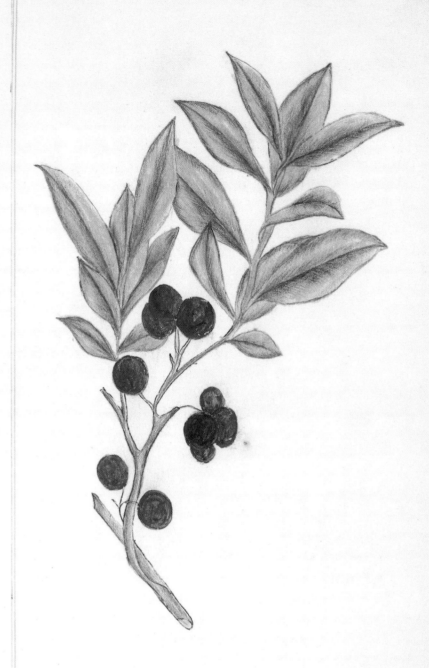

Order Cupuliferae.

Fagus sylvatica.

Beech.

A common forest tree. in U.S.
& Can. 50 to 80 ft high.

May.

Order Ericaceae.

Gaylussacia resinosa.

Black Huckleberry.

In woods and pastures. Can to
Va. Berries sweet & eatable.

May.

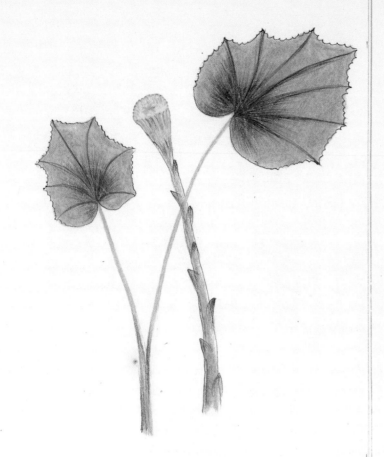

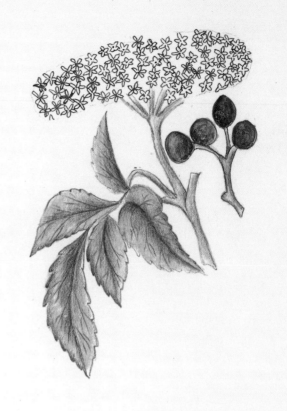

Order Compositae.
Tussilago farfara.
Colt's foot.
 A low plant in wet places
by brooks & lakes N. & M. States.
 Early Spring.

Order Caprifoliaceae.
Sambucus Canadensis.
Elder.
 A common shrub 6 to 10 ft high in
hilly pastures & woods, U.S. & Can.
Berries dark purple.
 May. July.

Order Lycopodiaceae
Lycopodium dendroideum
Club Moss. Common
in woods & readily distin
guished.
 July

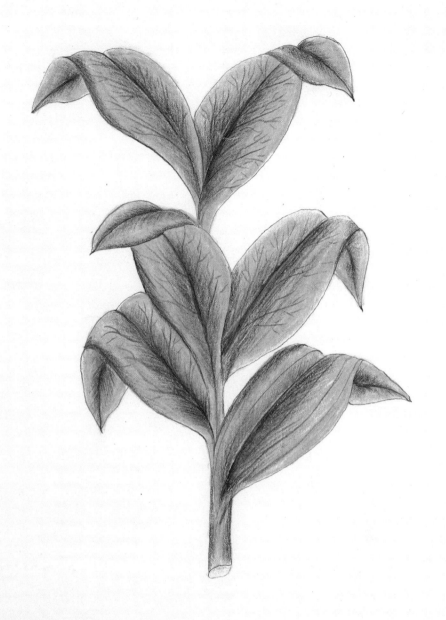

Order Melanthaceae.
Veratrum viride.

False Hellebore.

A coarse-looking plant in meadows & swamps, Can to Ga.
July.

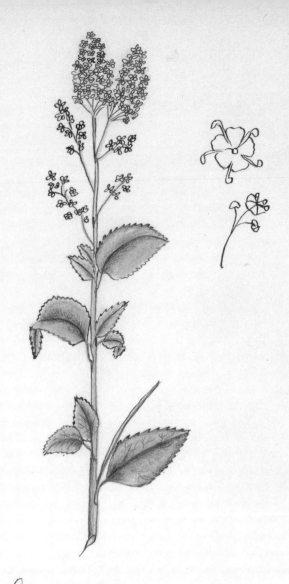

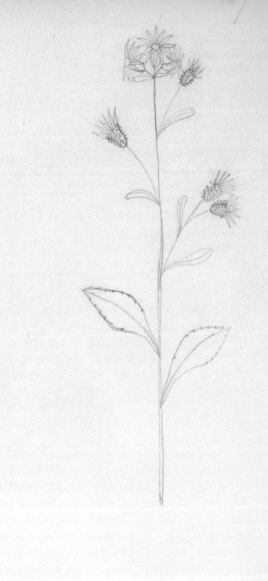

Order Rhamnaceae.
Ceanothus Americanus.
Jersey Tea. Red Root.
A small shrub, found in
woods and groves, N.S. & Can.
June.

Order Compositae.
Aster ericoides
Aster

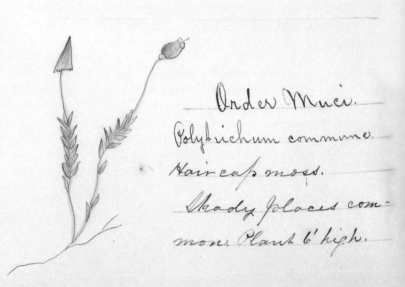

Order Musci.
Polytrichum commune.
Hair cap moss.
Shady places com-
mon. Plant 6' high.

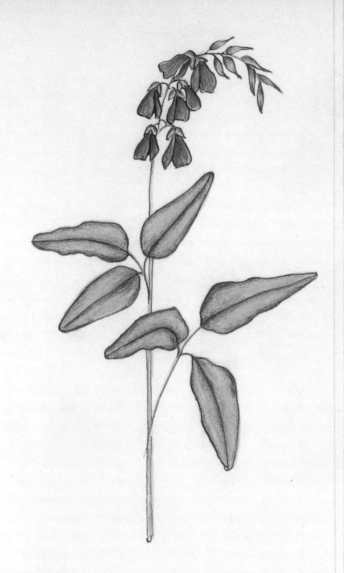

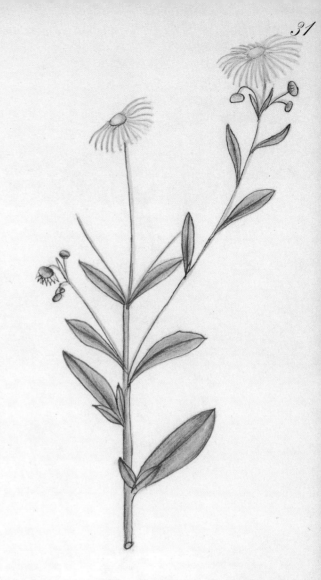

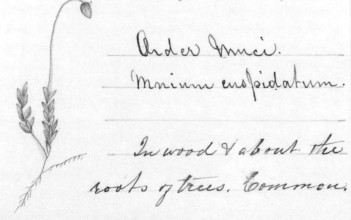

Order Leguminosae.
Desmodium paniculatum.
Bush Trefoil.
　　A handsome species
found in woods, U.S. & Can.
　　　　July & Aug.

Order Musci.
Mnium cuspidatum.

　　In wood & about the
roots of trees. Common.

Order Compositae.
Aster puniceus.
Aster.　Large, handsome, common
in swamps & ditches & dry soils,
Can & U.S.
　　　　Aug & Sept.

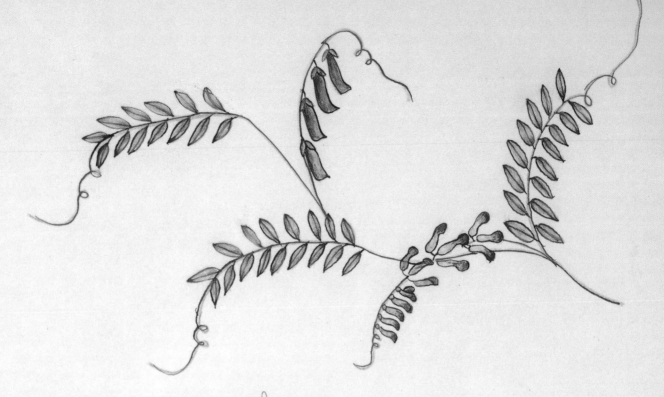

Order Leguminosae.
Vicia Cracca.

Tufted Vetch.

A slender climber, about fences and hedges, New
England and Canada. July.

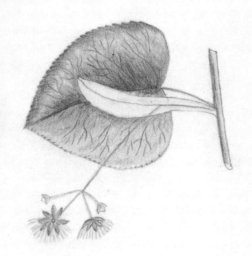

Order Tiliaceae
Tilia Americana.

Bass wood.

A common forest tree, in
the northern & middle states
June,

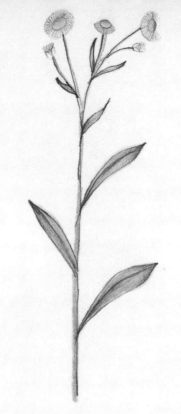

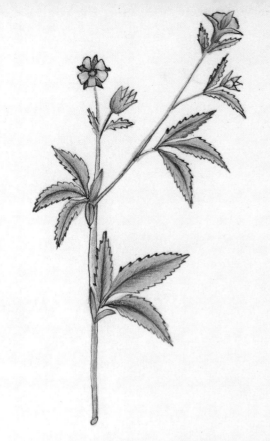

Order Compositae.
Erigeron Canadense.
Common Fleabane.
　By roadsides & in fields
throughout North America.
　　　Aug. Nov.

Order Rosaceae.
Potentilla Norvegica.
Cinquefoil.
　Old fields and thickets. Arc.
Am to Car.
　　　July & Sept.

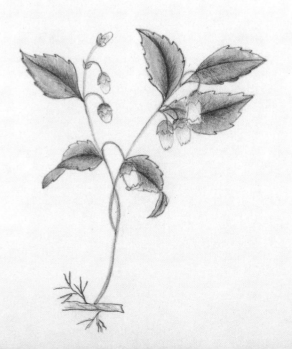

Order Ericaceae.
Gaultheria procumbens.
Checkerberry.
　Common in woods & pastures,
Can. to Ky.

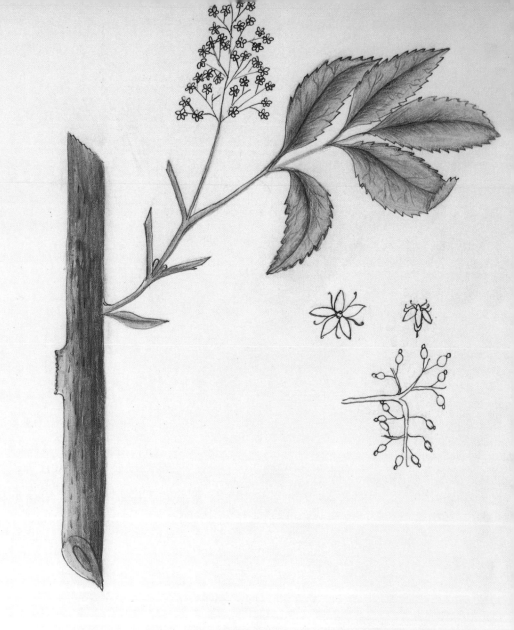

Order Caprifoliaceae.
Sambucus pubens.

Panicle Elder.
A common shrub, in hilly pastures and woods.
Hudson's Bay to Car.

May & June.

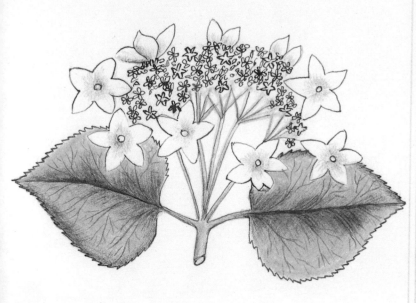

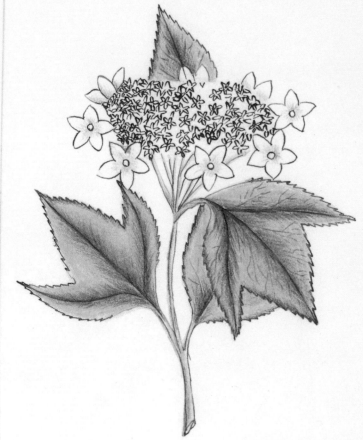

Order Caprifoliaceae.
Viburnum lantanoides.
Hobble Bush.
 An ornamental shrub, com-
mon in rocky woods of New
England.
 May.

Order Caprifoliaceae.
Viburnum Opulus.
High Cranberry.
 A handsome shrub, in woods
& borders of fields. Northern States
& Brit. Am.
 June.

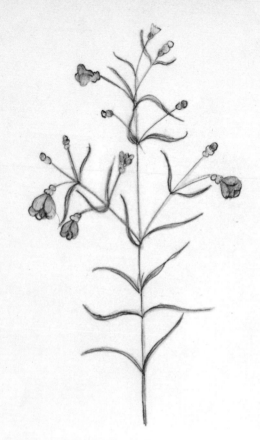

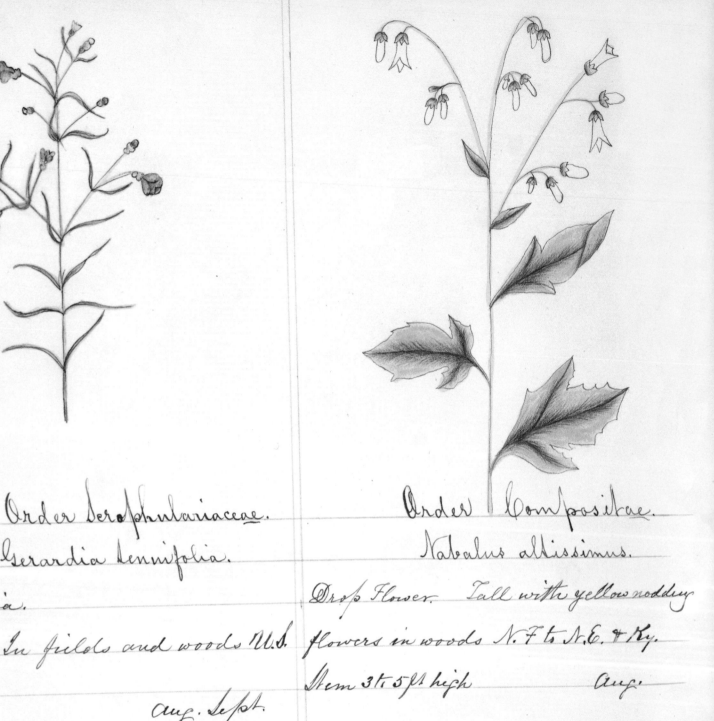

Order Scrophulariaceae.

Gerardia tenuifolia.

Gerardia.

In fields and woods U.S.
+ Can.

Aug. Sept.

Order Compositae.

Nabalus altissimus.

Drop Flower. Tall with yellow nodding
flowers in woods N.F to N.E. & Ky.
Stem 3 to 5 ft high Aug.

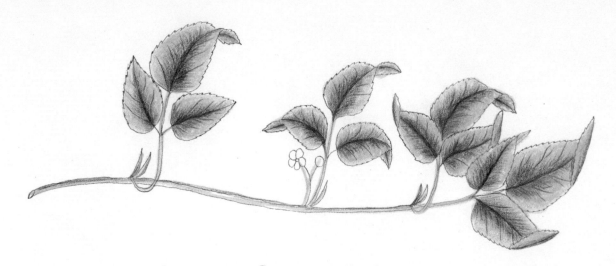

Order Rosaceae.
Rubus hispidus.

Trailing Blackberry. In damp woods & by the road side
Can to Car.
 May & June.

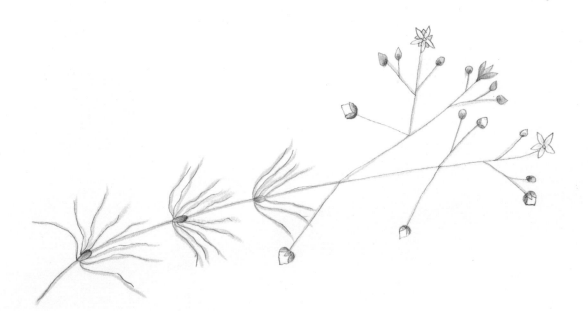

Order Caryophyllaceae.
Spergula arvensis.

Spurry. A weed in cultivated grounds, Can to Ga.
 May, Aug.

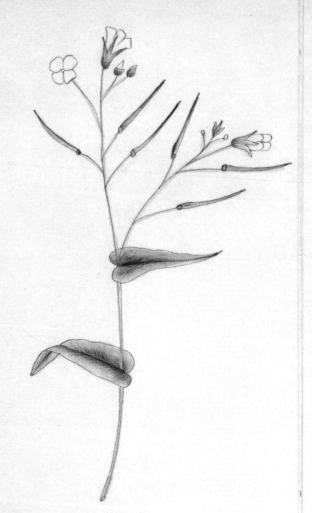

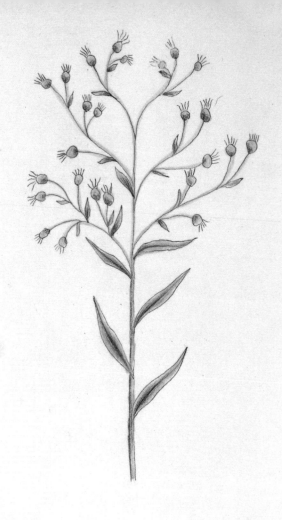

Order Cruciferae.
　　Brassica campestris.
Cale.
　　Cultivated fields & waste
places.　　　　　Jn & July.

Order Compositae.
　　Aster Multiflorus.
Aster. A very bushy aster, with nu-
merous small flowers. Rocks & dry
fields. U.S.　　　　　Sept

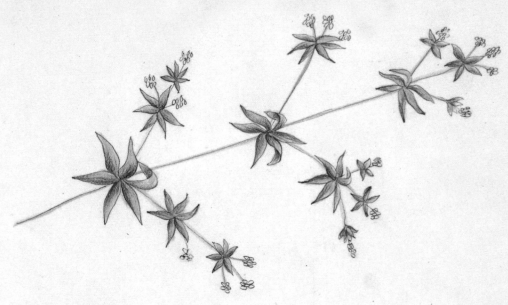

Order Rubiaceae.
Galium asprellum.

Rough Cleavers.

Common in thickets & low grounds. Can & U.S.

July.

Here Sister Helena left thirty pages blank,
perhaps to allow for specimens to come later.
She resumed her work with a study of ferns.

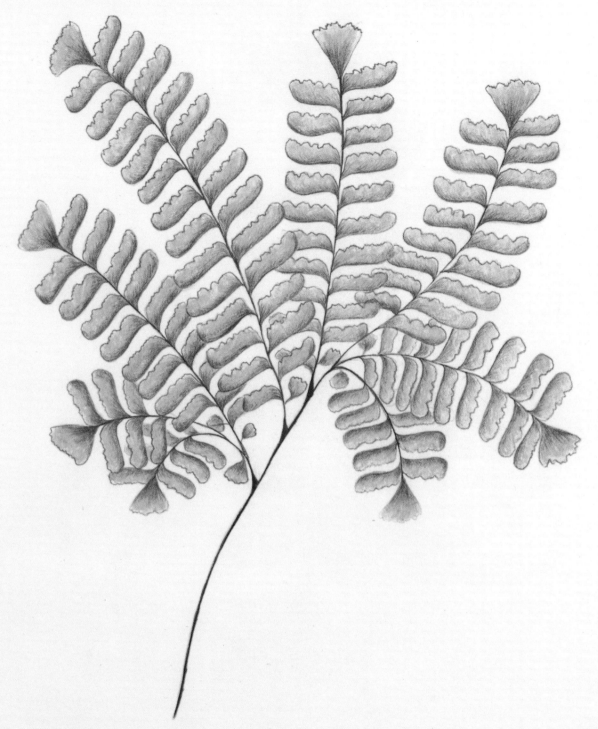

Order Filices.

Adiantum. pedatum.

Maiden Hair.

A beautiful fern. abounding in damp. rocky woods.

Stipe glossy purple, approaching to a jet black.

July.

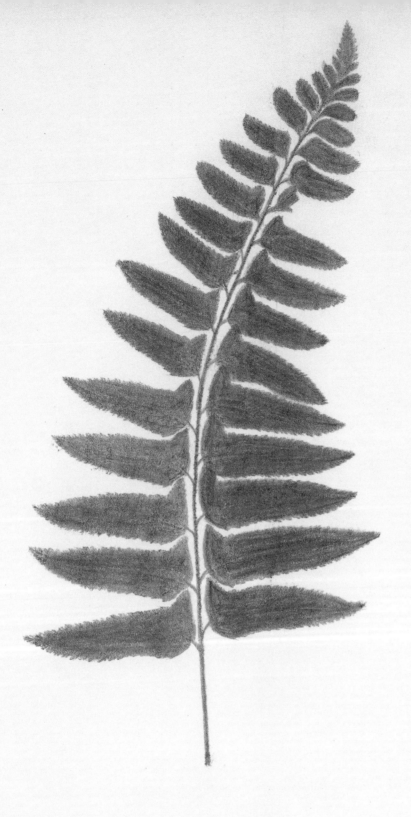

Order Filices.

Aspidium acrostichoides.

Shield Fern.

Common in rocky shades.

June – Aug.

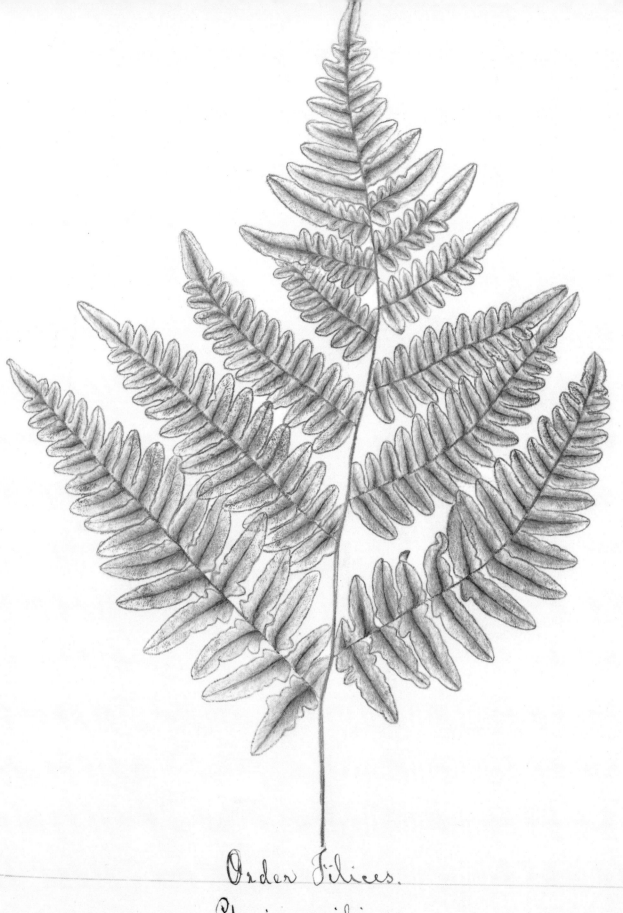

Order Filices.

Pteris aquilina.

Rock Brake.

Abundant in woods, pastures and waste grounds.

73

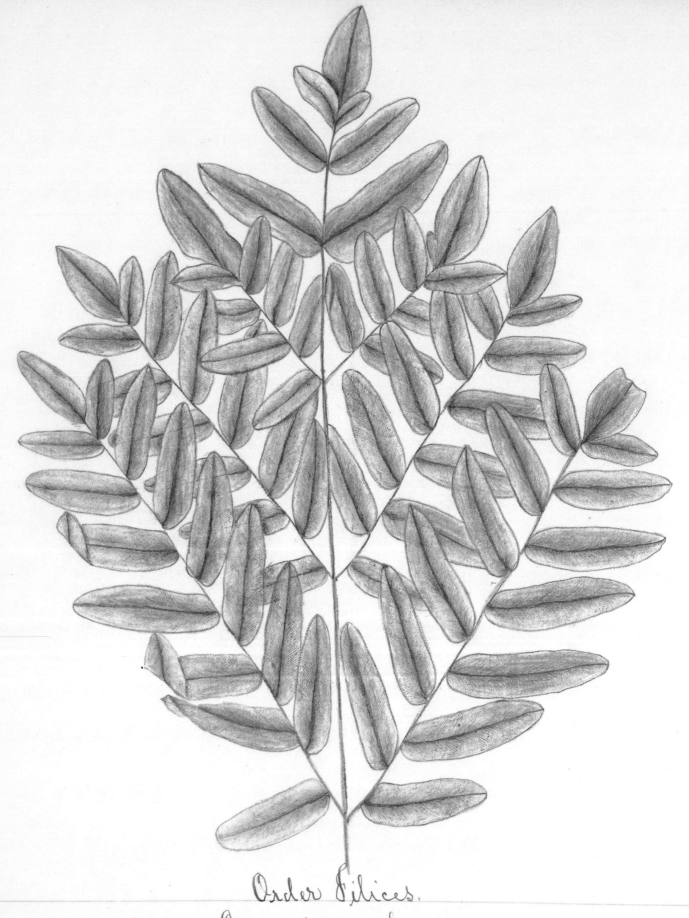

Order Filices.
Osmunda regalis.

A large & beautiful fern in swamps & meadows. The fronds
are 3 ft high.

June.

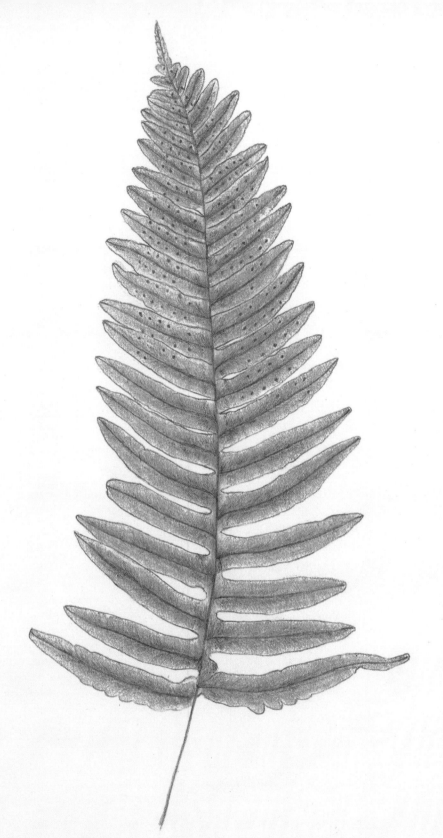

Order Filices.

Polypodium vulgare.

Common Polypod.

On shady rocks and in woods. forming tangled patches.

July.

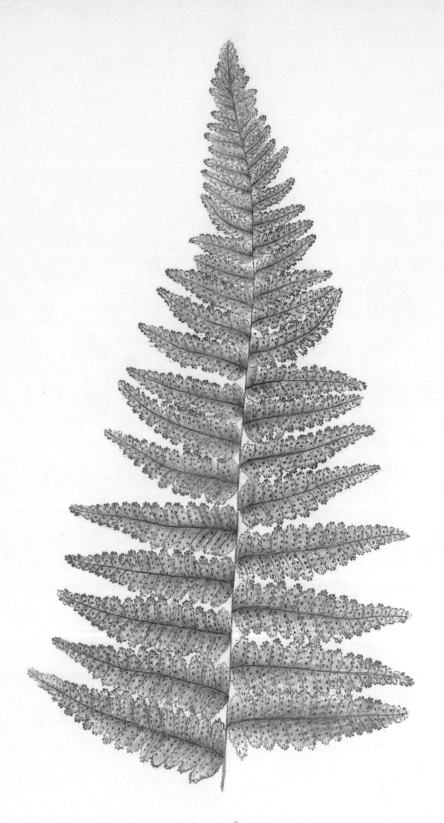

Order Filices.

Dicksonia pilosinscula.

Fine haired mountain fern.

A large, delicate fern in pastures, roadsides, among rocks and stones.

July.

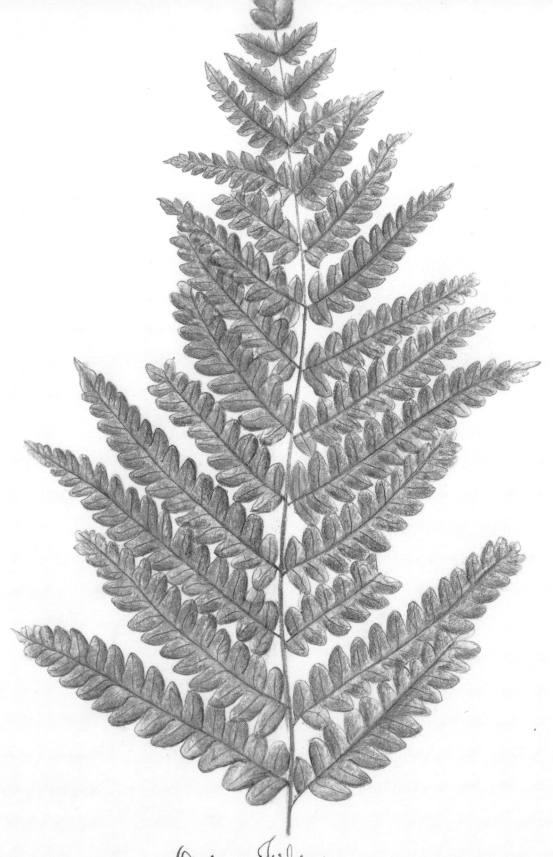

Order Filices.

Osmunda cinnamomea.

Cinnamon Fern.

This is one of the largest of our ferns, growing in swamps
and low grounds. Fronds invested with a cinnamon colored wool.
June.

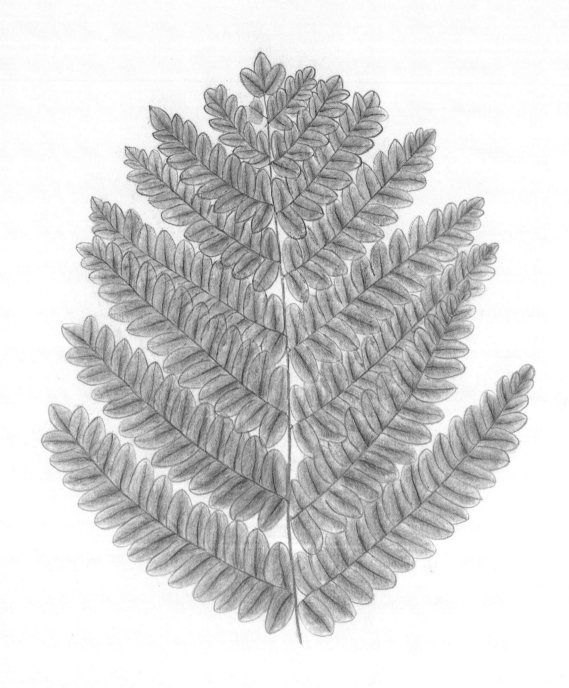

Order Filices.

Osmunda Claytonia.

Interrupted Flowering Fern,

Common in low grounds. Fronds interrupted near the
middle with 2 to 4 pairs of fertile leaflets.

June.

Afterword

CORA HELENA SARLE
(1867–1956)

IN 1886, AN ASPIRING YOUNG SHAKERESS began to draw the wild and cultivated plants growing on the extensive property of the Shaker community in Canterbury, New Hampshire. Although untrained in the arts of drawing and watercolor, and unschooled in botany, young Cora Helena Sarle had a skilled mentor in Shaker Elder Henry Clay Blinn. At age sixty-two, Blinn knew every tree and plant in the community, having personally planted or tended many of them.

The cataloging of local plants was ostensibly designed to provide Helena with healthy outdoor activity to counteract the threat of consumption, as well as with an opportunity to learn. The project also fit into Elder Henry's larger vision for the Canterbury community. Helena's plant journals would systematically record, in Shaker fashion, the botanical world of the Canterbury Shakers. They would also document for future generations Henry's own extensive botanical knowledge, just as a few years later, in 1891–92, he would begin a written history of the Canterbury Shakers based on his own meticulous scrutiny of the community's records. The botanical journals would also provide a teaching tool for the community's young people and perpetuate the knowledge that had been accumulated since Canterbury's call to order in 1792.

By the time Helena began her work, the gardens at Canterbury were nearly one hundred years old, but the glory years of the Physician's Botanical Garden (laid out in 1817 by Dr. Thomas Corbett) had passed. By 1886, the knowledge of Shaker plant lore was fading as the herbal medicine industry declined.

Today we have no record or oral tradition about the community's use of Sister Helena's journals. We do know she signed the Shaker Covenant in 1888, and remained a devoted member of the community

until her death in 1956. Helena retained possession of the journals until 1938 when she gave them to a young protégé of hers, Sister Bertha Lindsay. Helena never lost her love of plants, gardening, or art. Late in life she returned to flower and landscape painting. Her works—seen today in many media—were done to please her Shaker Sisters and to sell to the public. The more private works include the globes of electric lights, umbrella stands, pin boxes, and large flower paintings for the Sisters' sitting room in the Dwelling House. The public works include small oil and watercolor landscapes and views of Shaker buildings, particularly the Meeting House.

Sister Helena's spirit lives on in many ways at Canterbury Shaker Village, now a National Historic Landmark site and popular museum. The small studio where she worked on the journals in the 1880s survives on the second floor of the Syrup Shop. An easel and studio in the Sisters' Shop remain from her later years, as do a few of the flower beds she lovingly planted in order to provide subjects for her flower painting. The Village also has her cornet, a reminder of another aspect of her health therapy and her participation in the life of the community as a member of the Shaker orchestra, which performed regularly for "entertainments" within the community.

The delicate drawings of Cora Helena Sarle are exquisite expressions of a young woman in the process of committing herself to a life of Shaker order. The Shakers, in return, gave freely of their love, beauty, and knowledge. Her journals are the offering of her heart, mind, and soul to the community and the Shaker way. We are privileged, in this book, to share the intimacy of that gift.

SCOTT T. SWANK
President
Canterbury Shaker Village

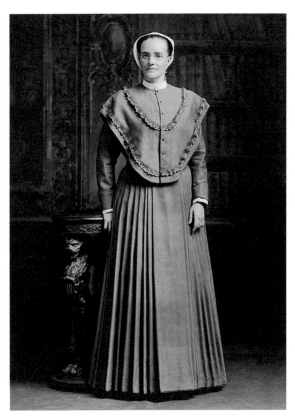

Sister Cora Helena Sarle
on a visit to
a photographic studio
in Concord, New Hampshire

PLANT NAMES

The botanical and common names that follow have been
transcribed directly from Sister Helena's plant journals,
retaining all original spelling and punctuation.

Notebook One

1. *Lobelia Cardinalis* / Cardinal Flower

2. *Comptonia asplenifolia* / Sweet Fern

3. *Diplopappus umbellatus* / Aster

4. *Polygonum Persicaria* /
 Heart-weed. Smart-weed

5. *Capsella Bursa pastaris* / Shepherd's Purse

6. *Galeopsis tetrahit* / Hemp Nettle

7. *Maruba cotula* / Mayweed (left)
 Lupinus perennis / Lupine (right)

8. *Geranium maculatum* /
 Spotted Geranium (left)
 Chimaphila maculata / Princes Pine (right)

9. *Rubus hispidus* / Trailing Blackberry (top)
 Spergula arvensis / Spurry (bottom)

10. *Nabalus altissimus* / Desso Flower

11. *Rubus odoratus* / Mulberry

12. *Oenothera pumila* / Evening Primrose

13. *Hedeoma pulegioides* /
 Amer. Pennyroyal. Squawmint (top)
 Sassafras officinale / Sassafras (bottom)

14. *Viola cucullata* / Wood leaved violet (top)
 Antigramma rhizaphylla /
 Walking Fern (bottom)

15. *Potentilla Canadensis* /
 Cinquefoil. Five finger (top)
 Larix Americana /
 Larch. Tamarack (bottom)

16. *Kalmia angustifolia* /
 Sheep poison. Calico Bush

17. *Erythronium Americanum* /
 Gap toothed violet, Yellow Erythronium

18. *Chenopodium album* / Pigweed

19. *Rumex acetossella* /
 Field sorrel. Sheep sorrel

20. *Ranunculus abortivus* /
 Round leaved crowfoot

21. *Agrostemma Githago* / Corn cockle

22. *Trifolium procumbens* / Yellow Clover

23. *Chelidonium majus* / Celandine

24. *Polygala paucifolia* / Milkwort

25. *Brunella vulgaris* / Self heal. Blue curls

26. *Spirea tomentosa* / Hardhack

27. *Brassica campestris* / Cale

28. *Ranunculus acris* / Buttercups

29. *Mitchella repens* / Partridge Berry (top)
 Gaultheria procumbens /
 Checkerberry (bottom)

30. *Potentilla argentea* / Silver weed (top)
 Tilia Americana / Bass wood (bottom)

31. *Majanthemum bifolium* /
 Two leaved Solomon's Seal

32. *Cerastium vulgatum* /
 Mouse ear Chick weed

33. *Sagittaria variabilis* / Arrow Head

34. *Bidens frondosa* /
 Leafy Burr Marigold. Beggar ticks

35. *Polygonum dumetorium* / Hedge Bindweed

36. *Asclepias cornuti* / Common Silkweed

37. *Dalibarda repens* / False Violet (top)
 Physcomitrium pyriforme (bottom)

38. *Medeola Virginica* / Indian Cucumber root

39. *Trifolium arvense* / Hare's foot Trefoil

40. *Aralia nudicaulis* / Wild Sarsaparilla

41. *Polygonum arifolium* / Hastate Knotgrass

42. *Lobelia inflata* / Indian tobacco

43. *Eupatorium purpureum*

44. *Mentha Canadensis* / Horsemint

45. *Solanum dulcamara* / Bittersweet. Nightshade

46. *Impatiens fulva* / Touch me not. Jewel weed

47. *Polygonum sagittatum* / Scratch Grass

48. *Hepatica triloba* / Liverwort

49. *Agrimonia Eupatoria* / Agrimony

50. *Aster puniceus* / Aster

51. *Aster Multiflorus* / Aster

52. *Linaria vulgaris* / Common Toad Flax

53. *Epigaea repens* /
 Trailing arbutus. May Flower (top)
 Bartramia pomiformis / Apple moss (bottom)

54. *Chelone glabra* / Snake head. Turtle head

55. *Spergularia rubra* / Red sandwort (top left)
 Neronica serpyllifolia / Speedwell (top right)
 Acer rubrum / Red Maple (bottom)

56. *Cephalanthus occidentalis* / Button Bush

57. *Coptis trifolia* / Goldthread

58. *Achillea millefolium* / Millfoil. Yarrow

59. *Chimaphila umbellata* / Prince's Pine

60. *Apocynum androsaemifolium* / Dog's Bane

61. *Sisyrinchium Bermudianum* /
 Blue eyed grass (left)
 Calopogon pulchellus / Grass Pink (right)

62. *Barbarea vulgaris* / Winter Cress (top)
 Lycapodium dendroideum / Club Moss (bottom)

63. *Tussilago farfara* / Colt's foot

64. *Ranunculus reptans* / Creeping Crowfoot (top)
 Galium asprellum / Rough Cleavers (bottom)

65. *Pontederia cordata* / Pickerel Weed

66. *Veratrum viride* / False Hellebore

67. *Gentiana Andrewsii* / Closed Blue Gentian

68. *Trientalis Americana* / Chickweed Wintergreen

69. *Cypripedium acanle* / Ladys Slipper

70. *Amphicarpaea monoica* / Pea vine (top)
 Mnium enspidatum (bottom)

71. *Epilobium angustifolium* / Rose Bay

72. *Oxalis Acetosella* / Wood Sorrel (top)
 Polytrichum commune /
 Hair cap moss (bottom)

73. *Pyrola chlorantha* / Wintergreen

74. *Cornus Canadensis* /
 Low Cornel. Bunch plums (top)
 Cladonia coccinea / Cup Lichen (bottom)

75. *Trillium erectum* / Bath flower

76. *Sarracenia purpurea* / Pitcher plant

Notebook Two

1. *Cypripedium pubescens* / Yellow Slipper

2. *Chiogenes hispidula* / Boxberry (top left)
 Taxus Canadensis /
 Ground Hemlock (bottom left)
 Pogonia verticillata (right)

3. *Pogonia ophioglossoides* (left)
 Campanula rotundifolia / Hare bell (right)

4. *Mimulus ringens* / Monkey flower

5. *Prinos verticillatus* / Winter berry (top)
 Ranunculus reptans /
 Creeping Crowfoot (bottom)

6. *Gentiana crinita* /
 Blue fringed Gentian (left)
 Uvularia perfoliata / Mealy Bellwort (right)

7. *Dirca palustris* / Leather Wood (top)
 Linnaea borealis / Twin flower (bottom)

8. *Lupinus perennis* / Lupine

9. *Myrica cerifera* / Bayberry

10. *Lilium Canadense* / Yellow lily (top left)
 Geranium maculatum /
 Spotted Geranium (top right)
 Sassafras officinale / Sassafras (bottom)

11. *Tiarella cordifolia* / Bishop's Cap (left)
 Sanguinaria Canadensis /
 Blood root (right)

12. *Hypericum perforatum* /
 St. John's Wort (top left)
 Potentilla anserina /
 Silverweed (bottom left)
 Viola canina / Violet (top right)
 Viola cucullata / Violet (bottom right)

13. *Linaria vulgaris* / Toad flax (top left)
 Larix Americana /
 Larch. Tamarack (bottom left)
 Verbena hastata / Vervain (right)

14. *Bidens frondosa* / Leafy Burr Marigold

15. *Eupatorium purpureum* (left)
 Mentha Canadensis / Horsemint (right)

16. *Achilla millefolium* / Millfoil. Yarrow (left)
 Eupatorium perfoliatum /
 Thoroughwort (right)

17. *Rudbeckia laciniata* / Cone Flower

18. *Dasystoma flava* /
 Yellow Foxglove (top left)
 Acer Pennsylvanicum /
 Striped Maple (top right)
 Antigramma rhizaphylla /
 Walking Fern (bottom)

19. *Uvularia sessilifolia* / Wild Oats (top left)
 Physcomitrium pyriforme (bottom left)
 Oxalis stricta / Wood Sorrel (top right)
 Stellaria media / Chickweed (bottom right)

20. *Clintonia borealis* /
 Northern Clintonia (top left)
 Alsine stricta / Sandwort (bottom left)
 Rhus venenata / Poison Sumac (right)

21. *Polygonum dumetorum* /
 Hedge Bindweed (top)
 Anacharis Canadensis /
 Ditch Moss (bottom)

22. *Ranunculus Pennsylvanicus* (left)
 Erigeron Philadelphicum /
 White Weed (right)

23. *Ranunculus bulbosus* / Buttercups (top left)
 Bartramia pomiformis /
 Apple moss (bottom left)
 Sabbatia angularis (right)

24. *Vaccinium Pennsylvanicum* /
 Common Low Blueberry (top left)
 Spergularia rubra /
 Red Sandwort (bottom left)
 Antennaria plantaginifolia /
 Mouse ear (top right)
 Cladonia coccinea /
 Cup Lichen (bottom right)

25. *Hamamelis Virginiana* /
Witch Hazel (top left)
Amelanchier Canadensis /
Shad berry. June Berry (top right)
Acer rubrum / Red Maple (bottom)

26. *Asclepias tuberosa* / Butterfly Weed

27. *Fagus sylvatica* / Beech (left)
Gaylussacia resinosa /
Black Huckleberry (right)

28. *Tussilago farfara* / Colt's foot (top left)
Sambucus Canadensis / Elder (top right)
Lycopodium dendroideum /
Club Moss (bottom)

29. *Veratrum viride* / False Hellebore

30. *Ceanothus Americanus* /
Jersey Tea. Red Root (top left)
Aster / Aster (top right)
Polytrichum commune /
Hair cap moss (bottom)

31. *Desmodium paniculatum* /
Bush Trefoil (top left)
Aster puniceus / Aster (top right)
Mnium cuspidatum (bottom)

32. *Vicia Cracca* / Tufted Vetch (top)
Tilia Americana / Basswood (bottom)

33. *Erigeron Canadense* /
Common Fleabane (top left)
Potentilla Norvegica / Cinquefoil (top right)
Gaultheria procumbens /
Checkerberry (bottom)

34. *Sambucus pubens* / Panicle Elder

35. *Viburnum lantanoides* / Hobble Bush (left)
Viburnum Opulus / High Cranberry (right)

36. *Gerardia semifolia* / Gerardia (left)
Nabalus altissimus / Drop Flower (right)

37. *Rubus hispidus* / Trailing Blackberry (top)
Spergula arvensis / Spurry (bottom)

38. *Brassica campestris* / Cale (left)
Aster Multiflorus / Aster (right)

39. *Galium asprellum* / Rough Cleavers

70. *Adiantum pedatum* / Maiden Hair

71. *Aspidium acrostichoides* / Shield Fern

72. *Pteris aquilina* / Rock Brake

73. *Osmunda regalis*

74. *Polypodium vulgare* / Common Polypod

75. *Dicksonia pilosinseula* /
Fine haired mountain fern

76. *Osmunda cinnamomea* / Cinnamon Fern

77. *Osmunda Claytonia* /
Interrupted Flowering Fern